MW01145480

POSTCARD HISTORY SERIES

Early
Los Angeles County
Attractions

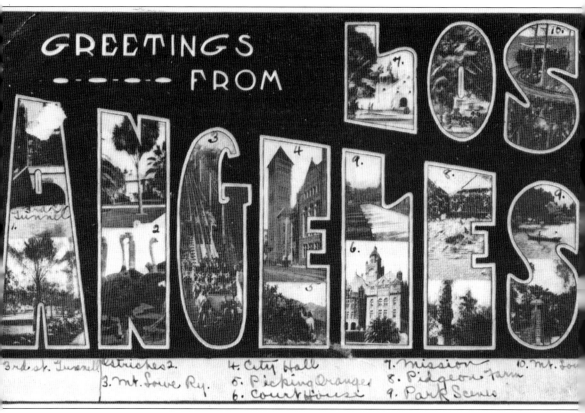

GREETINGS ····· FROM LOS ANGELES

3rd. st. Tunnel | Ostriches 2. | 4. City Hall | 7. Mission | 10. Mt. Low
1. | 3. Mt. Lowe Ry. | 5. Picking Oranges | 8. Pidgeon Farm
2. | | 6. Courthouse | 9. Park Scene

This early postcard showcases the variety of attractions that could be visited in the Los Angeles area. Some of the most popular attractions are visible, including Mount Lowe, Cawston's Ostrich Farm, the Pigeon Farm, a variety of park scenes, and Angels Flight in downtown Los Angeles.

ON THE COVER: On the front cover is an image of Venice of America, one of the most popular beach towns in Los Angeles County. Tourists delighted in swimming in the ocean and strolling out on the pleasure pier, where rides, a dance hall, and other amusements could be found. Styled after Venice, Italy, the resort town also featured canals, where visitors could enjoy a gondola ride. On the back is a view of Eastlake Park, one of the popular parks found in the Los Angeles area. Park visitors took advantage of the sunny climate by picnicking, strolling through the grounds, or boating on the lake. (Cory and Sarah Stargel collection.)

POSTCARD HISTORY SERIES

Early Los Angeles County Attractions

Cory and Sarah Stargel

ARCADIA
PUBLISHING

Copyright © 2008 by Cory and Sarah Stargel
ISBN 978-0-7385-5928-5

Published by Arcadia Publishing
Charleston SC, Chicago IL, Portsmouth NH, San Francisco CA

Printed in the United States of America

Library of Congress Catalog Card Number: 2008921010

For all general information contact Arcadia Publishing at:
Telephone 843-853-2070
Fax 843-853-0044
E-mail sales@arcadiapublishing.com
For customer service and orders:
Toll-Free 1-888-313-2665

Visit us on the Internet at www.arcadiapublishing.com

This book is dedicated to my sister,
Cassie Dawn Stargel-Brown.
We shall always miss you.

CONTENTS

ACKNOWLEDGMENTS

This book would not exist without the support we have received from our friends and family, especially our parents.

We would also like to thank our editor, Jerry Roberts; Devon Weston, our publisher; and all of the other wonderful people at Arcadia Publishing.

All of the postcards in this book are from the authors' collection.

And, in regards to Captain Spaulding, we give a special thanks.

INTRODUCTION

The city of Los Angeles was founded in 1781 with the land grant of four square leagues to which every organized Spanish pueblo was entitled. Until the 1880s, the city grew slowly, centered around a small business district. Much of the surrounding area was rural, with the local economy based on agriculture and ranching. This was all to change however, when the Santa Fe Railroad reached Los Angeles in 1885, providing competition for the Southern Pacific line, which had first reached the city in 1876. A hearty price war ensued, with ticket prices reaching record lows in 1887. Midwesterners and Easterners, presented for the first time with an affordable and convenient means of traveling west, jumped at the opportunity to visit California. Lured by the mild winters and the pleasant summers, many who came to visit decided to stay. The influx of new people set off a land boom, with new developments abounding and growth spreading in all directions.

In 1888, businessmen founded the Los Angeles Chamber of Commerce with the purpose of attracting more tourism by advertising the virtues of the Los Angeles vicinity. Promoting the sunny healthful climate, the organization placed advertisements in newspapers and magazines across the country and entered exhibits at various conventions and fairs. The advertisements worked, and even after the cooling of the land boom, tourists continued to flock to the Los Angeles area to visit the growing range of attractions found there.

By the dawn of the 20th century, tourism had been established as one of the region's major industries. Los Angeles, with its unique geography and unparalleled climate, offered a wide variety of amusement and recreational opportunities to be enjoyed by tourists and residents alike. With both the mountains and the ocean only a short ride from the city center, one could easily watch a mountain sunrise, have lunch in a downtown restaurant, and spend the afternoon strolling along the ocean shore. A variety of both beach and mountain resorts had been constructed by the early 20th century. The most popular mountain destination was Mount Lowe, where visitors ascended the summit by a cable incline. At the popular Los Angeles County beaches, visitors could swim in the surf or stroll out on the pier. Several beach towns also featured theaters, rides, and other carnival-like attractions, such as those found at the Pike in Long Beach and at the Venice of America resort.

Another popular way to take advantage of Southern California's sunny climate was to spend an afternoon relaxing at one of the region's many parks. Created in the 1880s with only a few parcels of land, the Los Angeles park system by the end of the 1930s boasted several large parks and dozens of smaller ones. A few of the parks consisted of lands that had been part of the original land grant founding Los Angeles, but most were received by the city as gifts from

individuals. Four of the city's sizable parks—Echo Park, Hollenbeck Park, Eastlake Park, and Westlake Park—featured lakes, while the two largest, Elysian Park and Griffith Park, were known for their motor roads and hiking trails. Griffith Park gained additional fame when a planetarium and observatory were constructed on its grounds in the 1930s.

The Los Angeles region was also known for a different, more bizarre type of park: the animal farm. Cawston's Ostrich Farm, located in South Pasadena since 1896, was one of Los Angeles County's most famous and popular attractions. A second ostrich farm, as well as an alligator farm, were located adjacent to Eastlake Park.

Aside from the wealth of outdoor activities, Los Angeles by the start of the 20th century offered a growing urban environment, home to a downtown district featuring amenities on par with any world-class city. Early promotional advertisements boasted that visitors to Los Angeles would find no lack of premier dining, shopping, or entertainment venues. The business district was filled with fine stores and hotels, attractive public buildings, and a myriad of theaters, many of which lured visitors with advertisements of being the largest, costliest, or simply the best.

Not far from downtown Los Angeles was another place of culture, Exposition Park. Here were found the Museum of History, Science, and Art; the California Exposition Hall; a formal rose garden; and the Coliseum sports arena.

By the 1920s, shopping districts began developing as attractions in their own right, including Wilshire Boulevard and Hollywood Boulevard. Lined with exclusive shops and well-known department stores, Wilshire Boulevard catered to motorists, offering a new experience from the traditional downtown. Hollywood Boulevard, also lined with high-end shops, was popular not just for its shopping opportunities, but also for the unique distinction of being the center of the movie industry. Whether one chose to visit the shops, a movie premiere, or another attraction, the sites of Hollywood held a special allure by offering a chance to glimpse a favorite star.

This book seeks to explore some of Los Angeles County's most famed attractions, covering the period from the 1890s up until World War II. These vintage postcards offer a unique look into the locales and attractions that drew people from all over the world to visit the Los Angeles area.

One

MOUNT LOWE

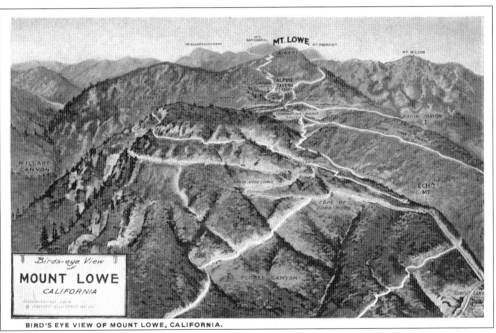

BIRD'S EYE VIEW OF MOUNT LOWE, CALIFORNIA.

This bird's-eye view shows the Mount Lowe Railway and resort, built by Thaddeus S. C. Lowe in the 1890s. One of Southern California's most popular attractions, the railway journey consisted of three parts. The first was by streetcar to Rubio Canyon, at the base of the mountain. There passengers transferred to a cable incline, seen at the bottom right corner, which would carry them up to the Echo Mountain resort. From here, tourists could travel on to Ye Alpine Tavern via a narrow-gauge rail line. The scenic mountain route, with landmarks such as the Granite Gate, Horseshoe Curve, and the Circular Bridge, can be seen winding up the mountain in the middle of the image.

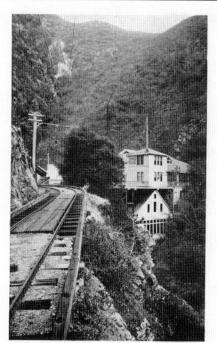

Rubio Canyon, on the Way to Mt. Lowe, near Pasadena, Cal.

This view shows the Rubio Hotel and Pavilion, located at the terminus of the Rubio Division streetcar line, where passengers transferred to the cable incline. Opened in 1893, the 10-room hotel occupied the upper floors, while the lower part of the structure was used as a dining room. This lower section was removed by 1903 because of flooding, and the hotel, used by that time only as a station office, was washed away in a 1909 storm.

While visiting Rubio Pavilion and Hotel, visitors could explore Rubio Canyon using a series of wooden stairways and paths constructed by Lowe. These walkways allowed tourists to view such scenery as Mirror Lake and several waterfalls. At night, Japanese lanterns were lit throughout the canyon above the pavilion.

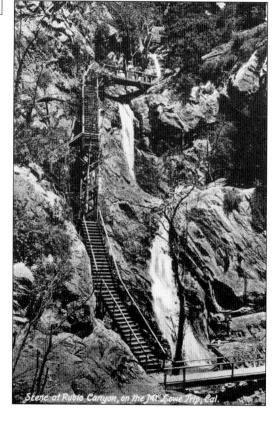

Scene at Rubio Canyon, on the Mt. Lowe Trip, Cal.

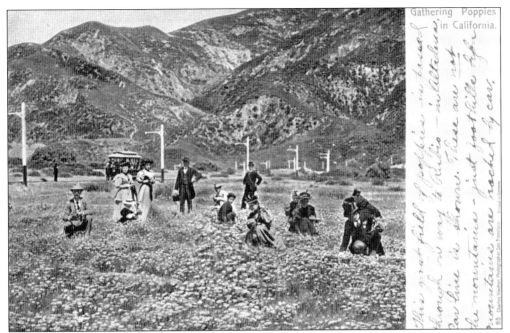

Gathering Poppies
in California.

This 1906 postcard shows passengers on their way to Rubio Canyon, with the waiting trolley car in the background. While the flowers were in bloom, the trolley would often stop so visitors could gather poppies. The trip from Pasadena to Rubio Canyon traveled along what is now Lake Avenue.

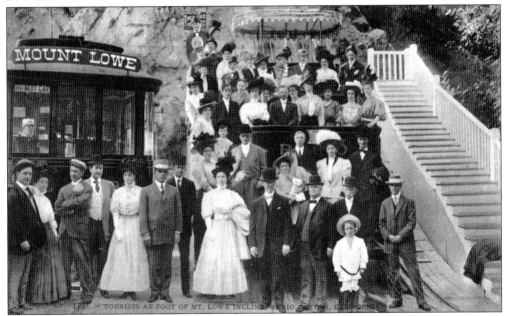

The passengers seen here are transferring from the Rubio Division trolley to the incline railway that would carry them to the summit of Echo Mountain. The incline cars, known as "opera cars" because of their resemblance to an opera box, were specially designed for the incline grade. Souvenir photographs were commonly taken at both the base and the summit of the incline by Charles Lawrence, official Mount Lowe photographer for 30 years.

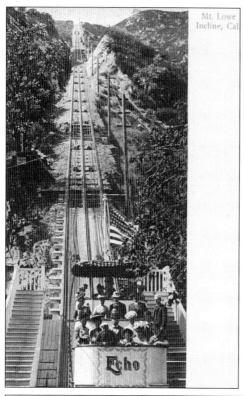

This postcard shows passengers about to ascend the incline. Andrew Hallidie, the pioneer of cable car engineering in San Francisco, was hired by Thaddeus Lowe to design and produce all the cables and mechanisms for his incline. Officially opened July 4, 1893, the 3,000-foot cable incline was regarded as one of the engineering feats of the century. Powered by electricity, the ascending trip took only about six minutes.

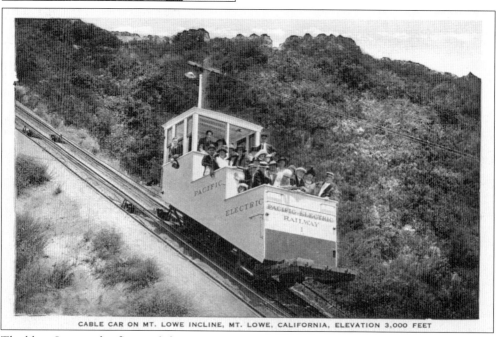

CABLE CAR ON MT. LOWE INCLINE, MT. LOWE, CALIFORNIA, ELEVATION 3,000 FEET

Thaddeus Lowe, who financed the Mount Lowe construction primarily from his own pocket, was eventually forced to sell when he could no longer meet his payments. In 1902, the operation passed into the hands of the Pacific Electric Railway. Seen in this postcard is one of the boxier incline cars Pacific Electric purchased to replace the aging opera cars.

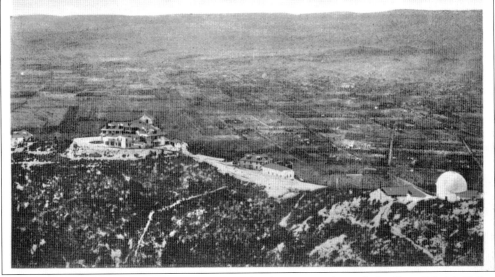

Mt. Lowe, One Mile High, near Los Angeles, Cal.

Shown here is an overlook of the summit of Echo Mountain and the San Gabriel Valley below. The summit resort was known as the White City, as the white-painted buildings were illuminated with hundreds of lights each night, making them visible throughout the region. To the far left is the Chalet, a 12-room hotel that opened with the incline in 1893. The largest structure, opened in 1894, was Echo Mountain House, a 70-room resort hotel. Also located on the summit were the Casino (used for social gatherings), the powerhouse, a zoo, and, at far right, the Observatory.

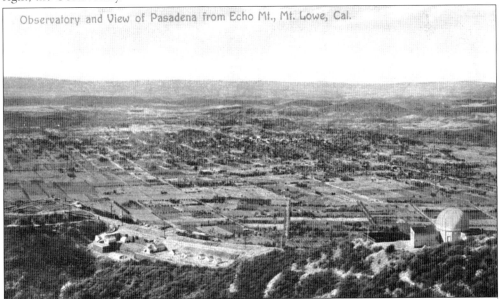

Observatory and View of Pasadena from Echo Mt., Mt. Lowe, Cal.

This is a later view of the summit. After Echo Mountain House burned in 1900 and a 1905 storm destroyed the majority of the other buildings, the summit became simply a place to transfer to the Alpine Division cars. The only remaining attraction was the Observatory; with the rest of the summit used as a maintenance yard and for employee housing.

13

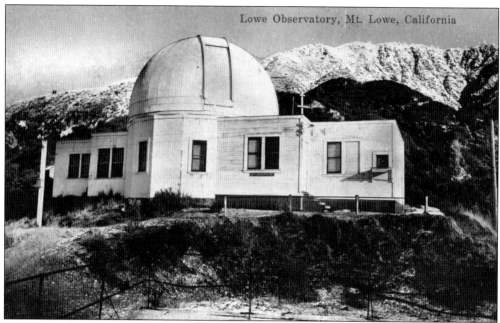

The Observatory, completed in 1894, allowed visitors to attend lectures by the resident astronomer while viewing the stars. Directed first by Dr. Lewis Swift, a renowned astronomer, and later by Dr. Edward Lucien Larkin, the Observatory remained popular until it was destroyed by a storm in 1928.

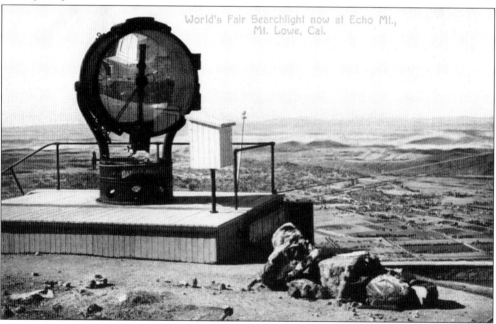

This searchlight was the largest in the world, having been built for the 1893 World's Columbian Exposition in Chicago. Lowe purchased the 11-foot-high light and installed it on Echo Mountain, where its 3 million candlepower could be seen 150 miles away. After the 1905 storm destroyed most of the buildings on the summit, a new powerhouse was built, with the searchlight installed on top.

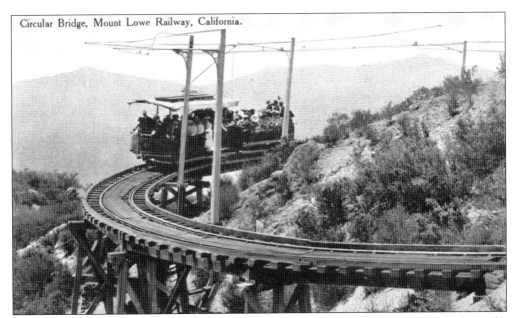

Circular Bridge, Mount Lowe Railway, California.

The Alpine Division was a narrow-gauge mountain railway traveling 3.5 miles from the terminus of the cable incline on the summit of Echo Mountain to the Alpine Tavern. The winding route passed over 18 trestles and went around 127 curves. Seen here is the Circular Bridge, which ascends the mountain while making almost a complete circle. Under the bridge was a 1,000-foot drop.

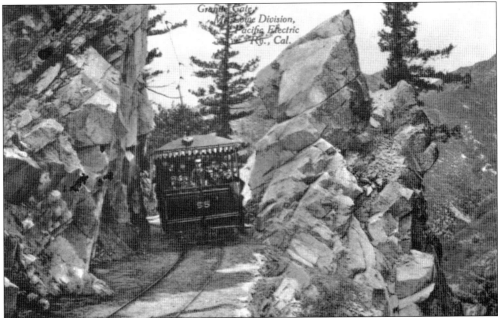

Granite Gate, Mount Lowe Division, Pacific Electric Ry., Cal.

When construction of the Alpine Division track began in 1894, crews were faced with not only placing tracks over treacherous drops, but also having to carve through some spots composed of solid granite. The Granite Gate seen here was formed when blasting crews cut a passage for the track. The dangerous construction work paid off, as tourists loved the ride on the Alpine Division for its rustic scenery and breathtaking views.

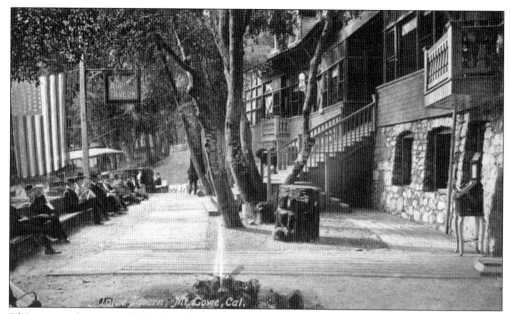

This postcard, postmarked 1907, shows Ye Alpine Tavern, the small Swiss-style hotel reached by the Alpine Division rail line. Lowe had originally intended to construct a variety of hotels along a line that continued much farther into the mountains, but because of a shortage of funding, these plans never materialized. Designed by architect Louis Kowski, Ye Alpine Tavern opened on December 14, 1895.

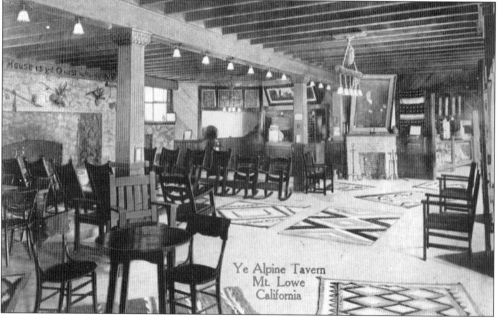

Simple but comfortable, the Alpine Tavern boasted five fireplaces on the main floor, two of which are visible in this view of the lobby. The tavern had 12 guest rooms, a dining room, and a billiards room, though many who took the 35-minute ride simply came to enjoy the scenery for the day. The lobby was designed with plenty of seating for visitors to await the trolley that would take them back down the mountain.

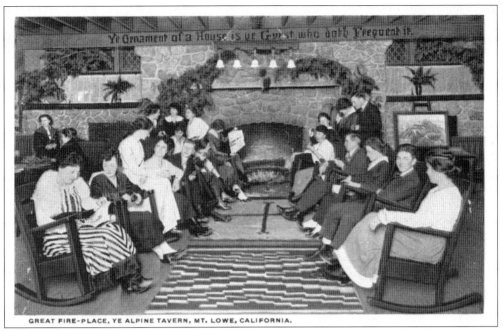

GREAT FIRE-PLACE, YE ALPINE TAVERN, MT. LOWE, CALIFORNIA.

Here visitors are seen relaxing in front of the main fireplace. While at the Alpine Tavern, guests were encouraged to enjoy the mountain scenery by taking a hike or renting a horse and riding along one of the many bridle paths. As a rustic retreat easily accessible from the city, the Alpine Division proved so popular that the tavern was enlarged and a number of cabins and tent cottages were constructed nearby.

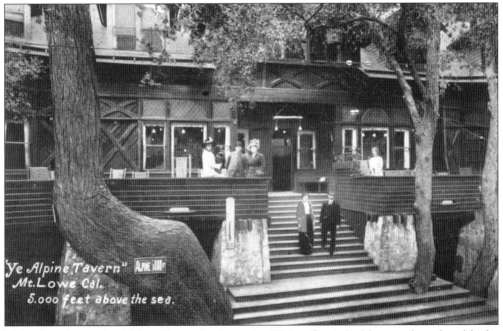

This view shows the Alpine Tavern in the early 1920s, after it had been enlarged and had a balcony added. The tavern was remodeled and expanded again in 1925, when it was renamed the Mount Lowe Tavern. Over 100,000 visitors made the trip each year during the 1920s.

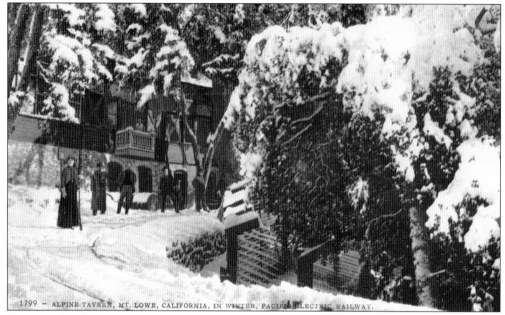

1799 — ALPINE TAVERN, MT. LOWE, CALIFORNIA, IN WINTER, PACIFIC ELECTRIC RAILWAY.

The occasional snowstorm at Alpine Tavern was cause for much excitement among Mount Lowe visitors. The rail line remained open so that visitors could enjoy the snow, although much work was required on the part of the maintenance crews, who had to clear snow from the tracks in order for the train to make the trip.

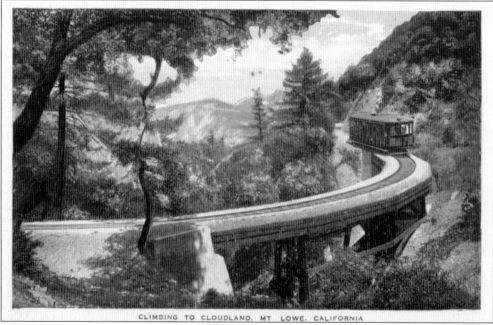

CLIMBING TO CLOUDLAND, MT LOWE, CALIFORNIA

The Mount Lowe Railway continued to be operated by Pacific Electric until 1936, when a fire burned the Alpine Tavern to the ground. Though Mount Lowe had been a favorite tourist attraction for 40 years, ridership had suffered from the Depression, and Pacific Electric chose not to rebuild. A final trip was made up the incline and over the Alpine Division in 1937 before the tracks were dismantled.

Two

Cawston's Ostrich Farm

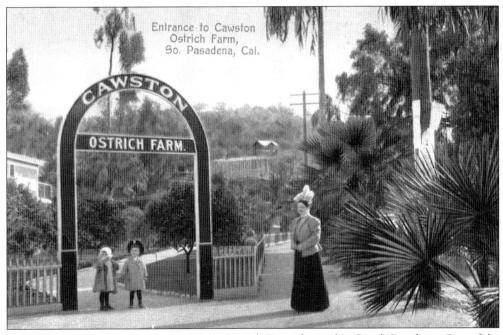

Shown here is the entrance to Cawston's Ostrich Farm, located in South Pasadena. One of the area's most popular attractions, the farm displayed ostriches of all ages in a pleasant amusement park–like setting a short trolley ride from downtown Los Angeles. The grounds also contained manufacturing facilities where ostrich feathers were turned into boas, fans, and other women's fashion items popular at the time.

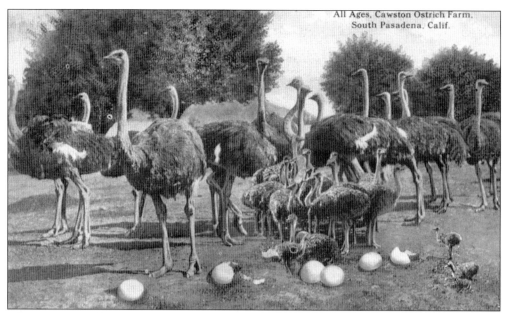

Edwin Cawston founded his farm in 1886, when he imported 50 ostriches from their native Africa. After breeding the ostriches for 10 years on a farm in Norwalk, Cawston moved them to South Pasadena. Ostriches of all sizes were put on display, from newly hatched babies to adults 7 or 8 feet tall.

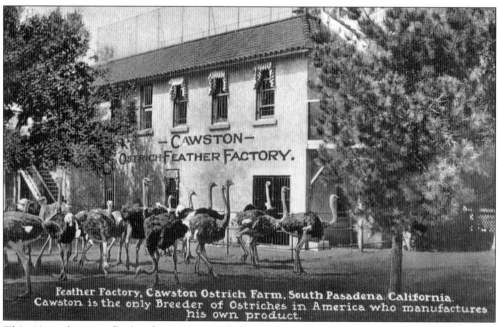

Feather Factory, Cawston Ostrich Farm, South Pasadena, California.
Cawston is the only Breeder of Ostriches in America who manufactures his own product.

This view shows a flock of ostriches with the manufacturing building behind. Cawston's ostrich feather products were known to be among the finest, advertised as having "life, luster, strength and beauty not found in other feather goods." All stages of production took place on the grounds, including the plucking, drying, dyeing, and curling of the feathers, as well as the assembly of finished products. The grounds also included a repair shop where old and ragged feathers could be remade into the latest fashion.

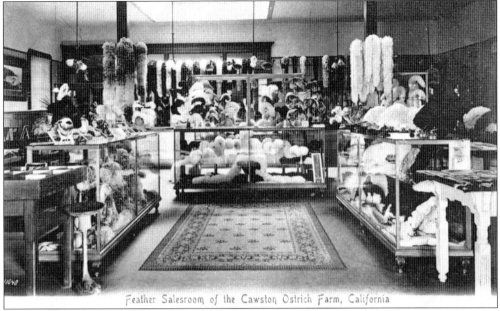

Feather Salesroom of the Cawston Ostrich Farm, California

Shown here is the salesroom of the ostrich farm. Visitors could purchase plumes, boas, fans, collars, stoles, and a huge variety of other feather products and Cawston memorabilia. By raising the birds himself, completing the entire manufacturing process on the premises, and selling direct to the public, Cawston was able to offer much lower prices than department stores and other retailers. Another showroom was located on Broadway in downtown Los Angeles, and at the height of his business, stores were also located in New York, Chicago, and San Francisco. Cawston also operated a huge mail-order department.

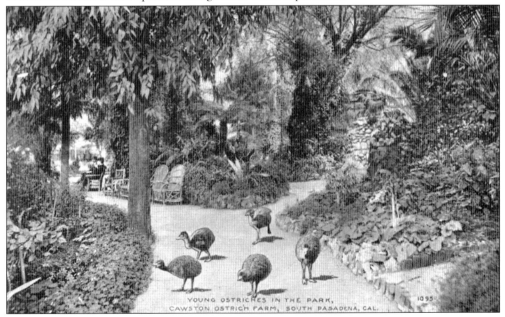

YOUNG OSTRICHES IN THE PARK,
CAWSTON OSTRICH FARM, SOUTH PASADENA, CAL.

Depicted is this view are baby ostriches wandering around the grounds of the ostrich farm, which was landscaped with live oaks, palm trees, orange trees, and flowers. Rustic shady paths lined with benches led between the different exhibits of the park.

Here is another view of the grounds. Cawston advertising described the park as a "semi-tropical, ever-green Ostrich Paradise, where people gather to enjoy the beauty of California flowers, plants, and palms, and to be entertained by the strange, immense and extremely foolish birds that live in the luxury of greenery instead of the desert wilds of their native land."

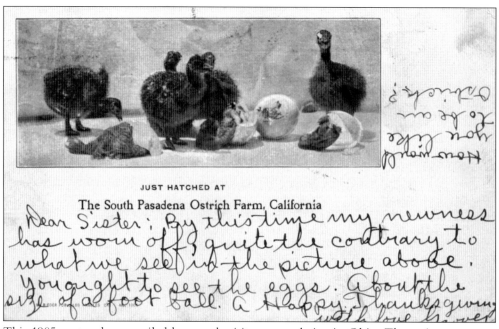

JUST HATCHED AT

The South Pasadena Ostrich Farm, California

Dear Sister; By this time my newness has worn off quite the contrary to what we see in the picture above. You ought to see the eggs. About the size of a foot ball. a Happy Thanksgiving

This 1905 postcard was mailed by a park visitor to a relative in Ohio. The written message remarks in part, "You ought to see the eggs. About the size of a football." Upside down next to the baby ostrich image, the visitor continues, "How would you like to be an ostrich?"

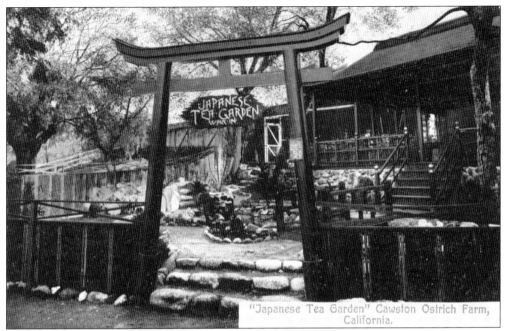

"Japanese Tea Garden" Cawston Ostrich Farm, California.

This postcard, postmarked 1909, shows the entrance to the Japanese Tea Garden at Cawston's Ostrich Farm. Visitors to the tea garden could relax from their ostrich sightseeing while enjoying a light lunch or afternoon tea.

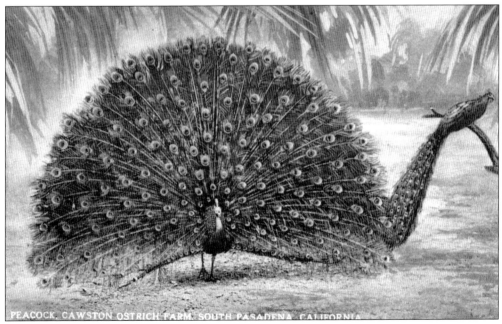

PEACOCK, CAWSTON OSTRICH FARM, SOUTH PASADENA, CALIFORNIA

The expansive semitropical grounds at the ostrich farm contained more than just ostrich pens. There was also a fish pond and an aviary of rare and beautiful birds, such as this peacock.

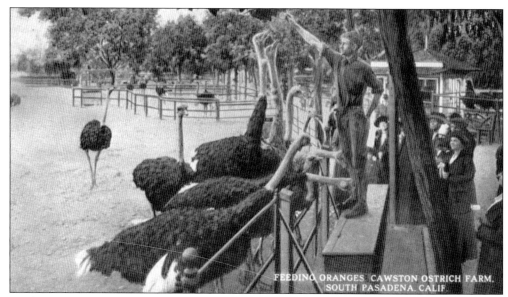

FEEDING ORANGES CAWSTON OSTRICH FARM. SOUTH PASADENA. CALIF

Feeding time was a popular event at the park. The ostriches would be fed whole oranges, as visitors delighted at watching the shapes they made as they slid down the ostriches' long necks. The ostriches were also known to enjoy consuming anything shiny, including jewelry, nails, and glass. Though rough objects, such as gravel and shells, were necessary for their digestion, the ostriches' main diet at the farm consisted of alfalfa, hay, and vegetables such as carrots, beets, and turnips.

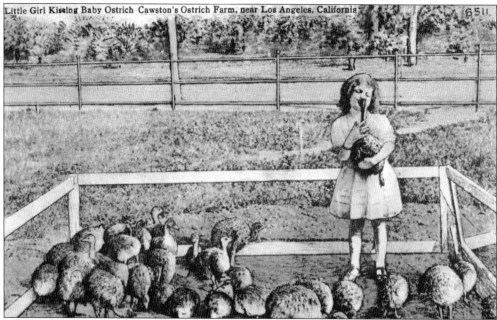

Little Girl Kissing Baby Ostrich Cawston's Ostrich Farm, near Los Angeles, California 651

Shown here is a young girl in a pen of baby ostriches. Ostriches mate for life, with the male sitting on the eggs at night and the female by day. Some eggs at the farm were also hatched by incubator. The ostriches were carefully raised so that they would provide superior plumes. Cawston feathers won gold medals and first prizes at world's fairs and exhibitions across the country.

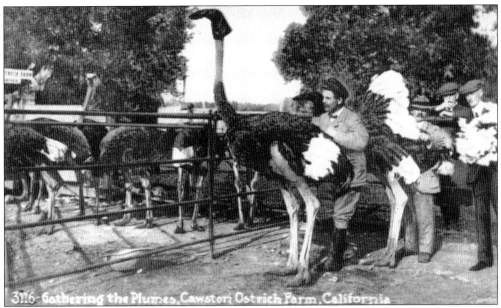

3116 - Gathering the Plumes, Cawston Ostrich Farm, California

Demonstrated in this postcard is the gathering of the ostrich plumes. The ostrich would be hooded, and one man would hold the wings steady while another handled the shears. The plumes were clipped, never plucked, in a process Cawston advertised as being approved by the Audubon society. Only the wing and tail feathers of male birds were clipped, as they were stronger and more lustrous than female feathers. The finest plumes were used to make Cawston products, with inferior feathers being sold to other producers.

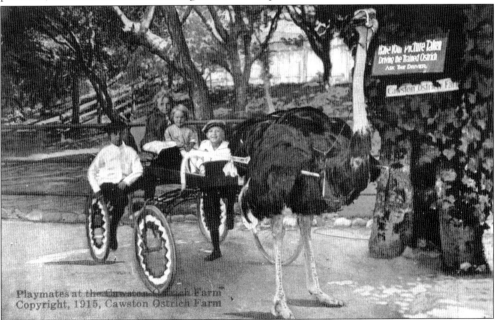

Playmates at the Cawston Ostrich Farm
Copyright, 1915, Cawston Ostrich Farm

In addition to touring the grounds and factory and observing daily activities such as feeding and feather collecting, visitors enjoyed posing with an ostrich for a souvenir photograph. Some ostriches were trained to pull carts, as in this image. The sign behind the ostrich advertised, "Have your picture taken driving the trained ostrich. Ask the driver."

25

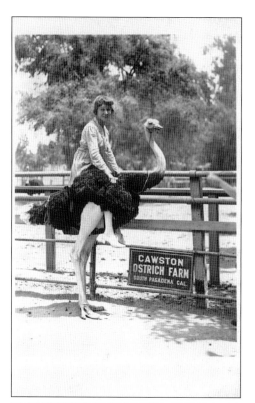

This real-photo postcard pictures a young woman astride an ostrich. These photographs were taken by Cawston staff and made into postcards for the visitor to purchase, either as mementos or to send home to relatives.

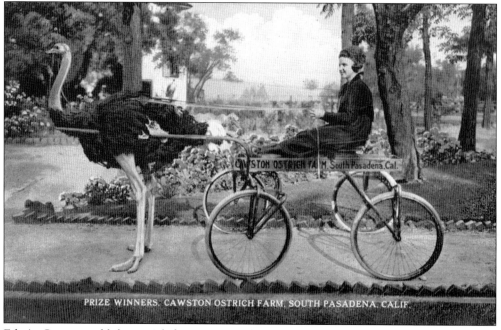

PRIZE WINNERS. CAWSTON OSTRICH FARM. SOUTH PASADENA. CALIF.

Edwin Cawston sold the ostrich farm in 1911, although it continued to operate under the same name. The farm remained a popular attraction even as styles began to change and the popularity of ostrich feathers waned. With the onset of the Depression, however, the farm was soon driven to bankruptcy. The farm closed in 1935, and the ostriches were relocated to other farms.

Three

IN AND AROUND
EASTLAKE PARK

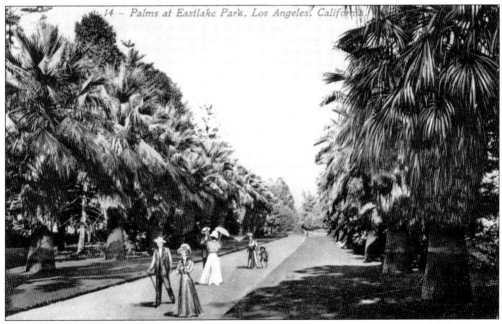

In this postcard, strollers are enjoying the Palm Walk at Eastlake Park. Originally known as East Los Angeles Park, Eastlake Park grew to become one of the largest and most popular in the network of Los Angeles city parks. It boasted a wider variety of amusements than did most city parks, and as other attractions began to locate adjacent to the park, the area became a favorite recreation destination.

Postmarked in 1909, this postcard shows one of the entrances to Eastlake Park. Most of the land for the park was acquired by the city in 1874 from John Griffin, who had purchased a large parcel on the east side of the city in 1863.

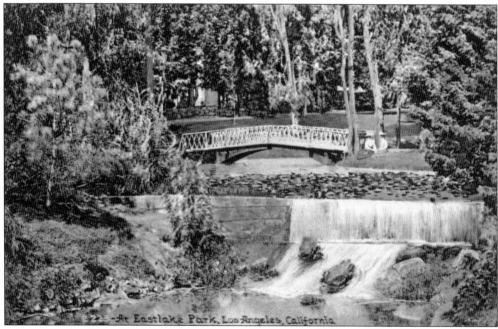

Shown here are two women picnicking by the bridge that was located over a portion of the park's 8-acre lake. The water lilies and small waterfall added to the scenic beauty of the park, which had been landscaped in an informal fashion with hundreds of varieties of trees and plants.

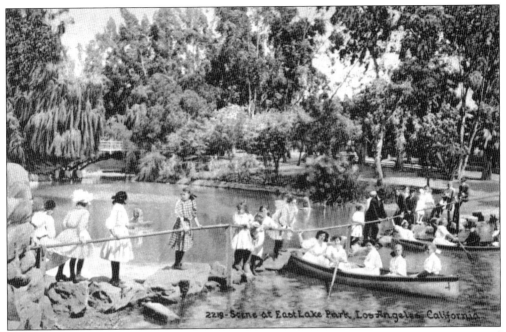

This view of Eastlake Park shows the popular stepping stones that traversed a shallow part of the lake. Only a short ride by streetcar from downtown Los Angeles, the park was crowded on weekends as visitors arrived to enjoy boating, strolling, and picnicking in the expansive natural surroundings.

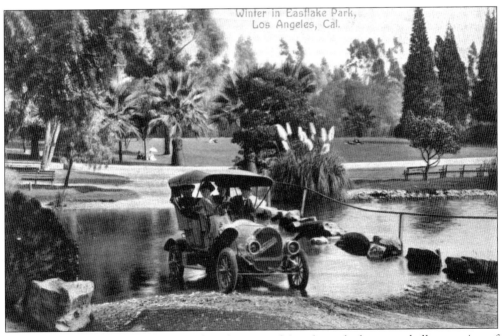

The carload of visitors in this image has chosen to drive through the same shallow section of the lake seen above. The stepping stones are to the right, and some of the vast lawns to be found in the park are visible behind.

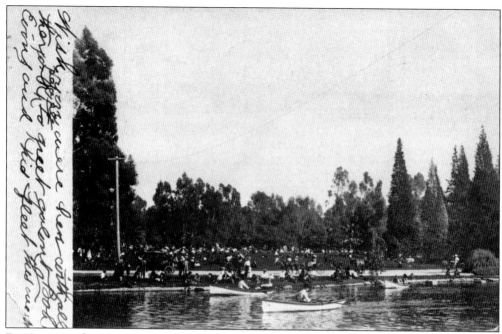

Boating was a favorite activity in Eastlake Park, as seen in this real-photo postcard, postmarked in 1908. Referring to the crowded scene on the shore and on the lake, the author of the postcard writes, "The same scene lasts the whole year around in sunny California."

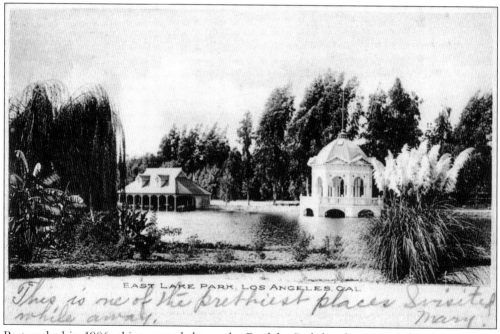

EAST LAKE PARK, LOS ANGELES, CAL.

Postmarked in 1906, this postcard shows the Eastlake Park boathouse, at left, where visitors could rent boats to spend a peaceful afternoon on the lake. The bandstand is on the right. The visitor who sent this postcard remarked, "This is one of the prettiest places I visited while away."

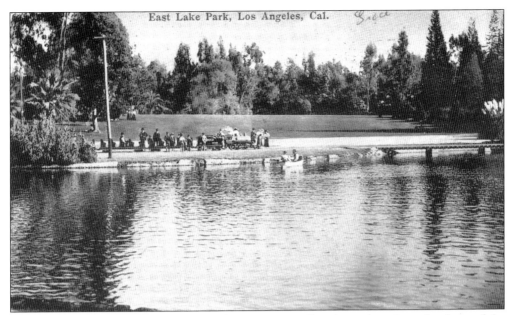

This postcard, stamped in 1907, shows the miniature railroad running along the shore of the lake. The train was an exact miniature of a real locomotive and was designed by John Coit, a retired Southern Pacific engineer. The amusement railway that carried passengers around the park caught the eye of Abbot Kinney, father of the Venice of America resort. In 1906, Coit built several miniature trains for use in Venice, although the Eastlake train was occasionally borrowed when one of the Venice trains needed repairs.

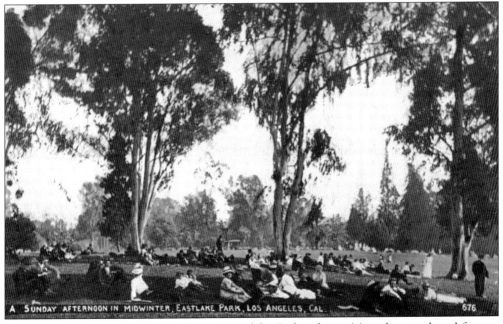

A SUNDAY AFTERNOON IN MIDWINTER, EASTLAKE PARK, LOS ANGELES, CAL. 676

This postcard shows the crowded lawn at Eastlake Park, where visitors have gathered for one of the popular Sunday concerts. The written message on the back of this unpostmarked card reads, "Here is the way it is here in the winter. We have been there in January and it looks just like this."

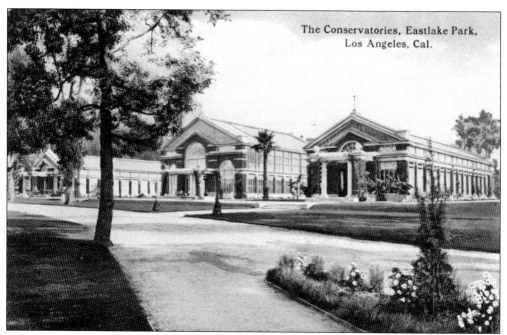

The Conservatories, Eastlake Park, Los Angeles, Cal.

The three large conservatory buildings at Eastlake Park were located at the eastern edge of the park. The conservatories housed a sizable collection of tropical plants. The printed description on the postcard reads, "One of the newer attractions here is the conservatories containing one of the finest botanical exhibits displaying a diversity of growth of rare plants from all parts of the country."

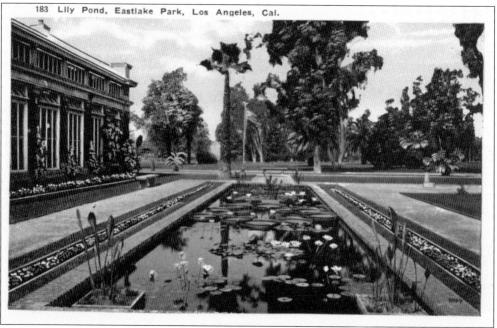

This view shows a small lily pond, with one of the conservatory buildings to the left. In addition to the lake, bandstand, and botanical exhibits, Eastlake Park had a carousel, playground, picnic grounds, tennis courts, and other recreational facilities.

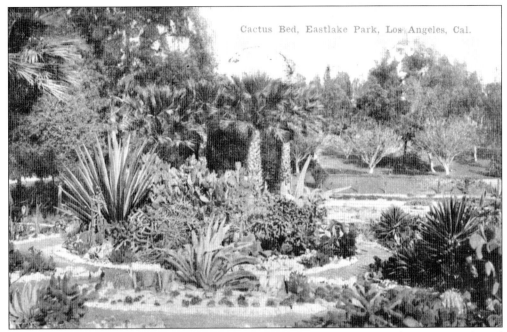

Depicted here is one of the cactus beds at Eastlake Park. Over 200 varieties of cactus were planted at the park, in addition to the hundreds of varieties of trees found on the park grounds.

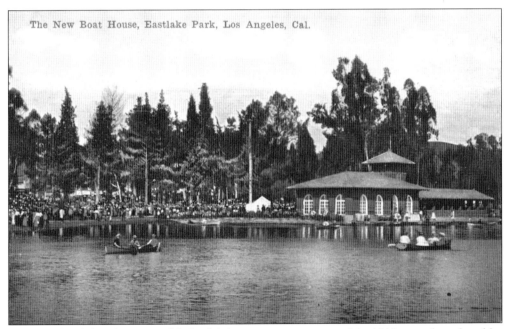

The new brick boathouse, visible in this image, was constructed in 1913 to replace the older wood-frame boathouse. The lake shore in this view is especially crowded, likely because of one of the special events that was frequently held at the park. In 1917, a few years after the new boathouse was dedicated, the park was renamed Lincoln Park.

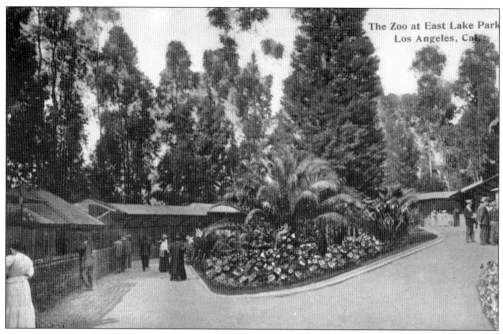

The visitors shown in this postcard are strolling through the city zoo that was located on park grounds. The first animals were put on display in 1885 and remained at Eastlake Park until 1913. At that time, they were moved to the new city zoo opening on the grounds of Griffith Park.

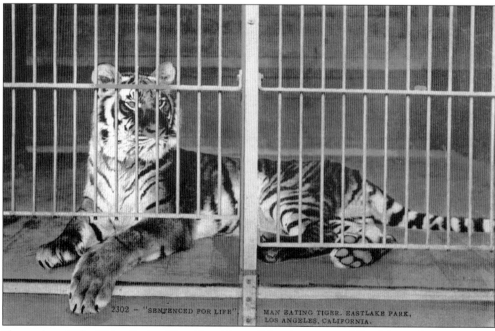

Shown here is the "Man Eating Tiger," resident of the city-operated Eastlake Park Zoo. One of the reasons cited for the zoo's move in 1913 was to provide a more natural setting, as there was not space in Eastlake Park to provide more than a small cage for each animal.

This view shows a totem pole and house that were part of the Indian Crafts Exhibit. A popular attraction for several years, the exhibit occupied 15 acres on Mission Road near Eastlake Park. This historic house and totem pole belonged to the Haida tribe's Chief Son-i-hat and was the only one at the time to have been sold and removed from Alaska.

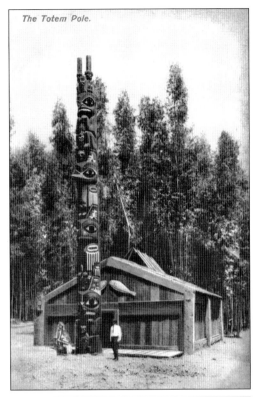

The Totem Pole.

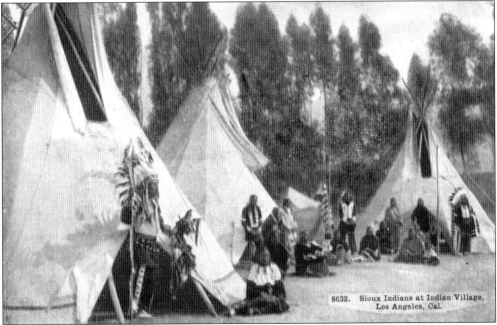

8632. Sioux Indians at Indian Village, Los Angeles, Cal.

This 1911 postcard depicts a group of Sioux Indians demonstrating their native dress and way of life as part of the Indian Crafts Exhibit. Both North and South American tribes were represented in similar displays. The exhibit also included halls displaying a large collection of Native American pottery, baskets, and Navajo blankets.

Los Angeles, Cal.

Hot Sulphur Springs.
Bathe at Eastlake Park for fun and health.

Shown in this postcard is the interior of the Hot Sulphur Springs at Eastlake Park. Like the hot-water baths found at nearly every popular beach town in Los Angeles County, this hot springs was advertised as having both amusement and health benefits.

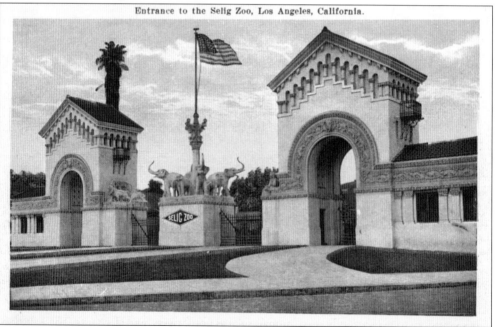

Entrance to the Selig Zoo, Los Angeles, California.

Located adjacent to Eastlake Park, Selig Zoo was founded by William Selig in 1911. Starting with only temporary quarters, the collection of animals grew within a short time to include over 700 animals. The entrance shown here was constructed for the park's formal dedication to the public in 1915. Italian sculptor Carlo Romanelli was hired to sculpt the animal friezes seen on the elaborate gates.

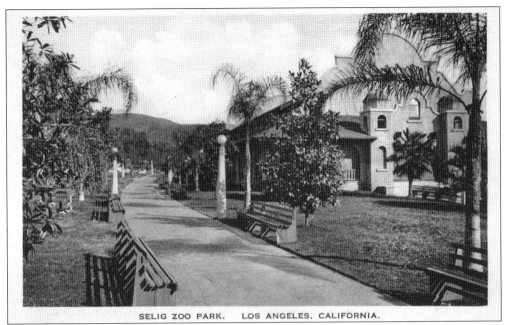

SELIG ZOO PARK. LOS ANGELES, CALIFORNIA.

This view shows some of the Selig Zoo grounds. In 1909, William Selig and his movie company, the Selig Polyscope Company, released the first movie filmed entirely in California, *The Heart of a Race Tout*. Selig constructed his first California studio in nearby Edendale shortly after its release, although all studio operations were later moved to Selig Zoo grounds. In addition to being a tourist attraction, Selig's animals were frequent stars in his motion pictures.

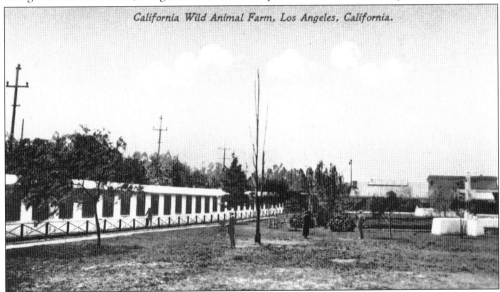

California Wild Animal Farm, Los Angeles, California.

These mission–style quarters housed animals such as lions, tigers, and elephants. The Selig Zoo grounds also contained a monkey pavilion, aviaries, corrals for non–wild animals such as horses, an amusement pavilion, movie stages, and costume rooms. During its many years of operation, the zoo was known by a variety of names, including Selig Zoo, California Wild Animal Park, and ZooPark. In the 1920s, after Selig's studio folded, the zoo was sold and renamed Luna Park Zoo. In its final years in the 1930s, it was known as the California Zoological Gardens.

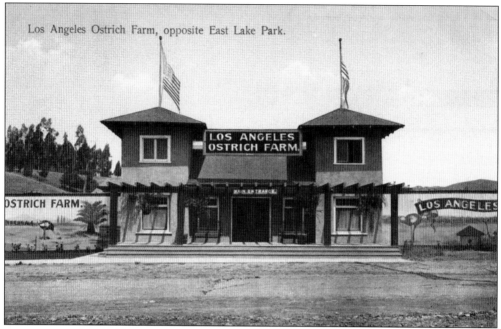

Los Angeles Ostrich Farm, opposite East Lake Park.

The Los Angeles Ostrich Farm was opened in 1906 by Francis Earnest. Located on Mission Road across from Eastlake Park, the farm offered visitors the chance to see exhibits of ostriches of all ages. As at Cawston's Ostrich Farm in nearby South Pasadena, visitors could purchase popular ostrich feather fashion items in the salesroom.

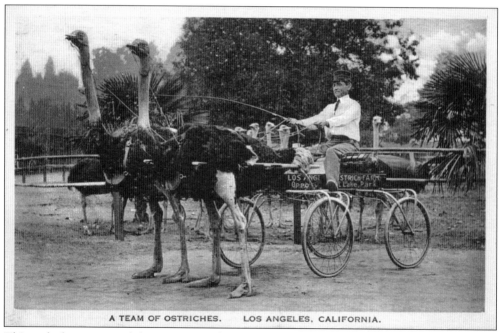

A TEAM OF OSTRICHES. LOS ANGELES, CALIFORNIA.

This real-photo postcard shows a team of ostriches hitched to a cart. One of the most popular sites at the Los Angeles Ostrich Farm was the racetrack, where ostrich riding and driving exhibits were held.

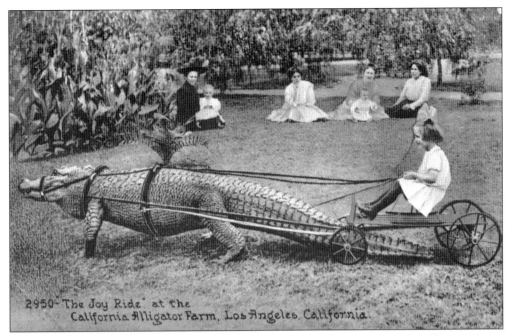

2950 "The Joy Ride" at the
California Alligator Farm, Los Angeles, California.

Postmarked in 1913, this postcard shows a young girl on an alligator ride at the Alligator Farm. Located across from Eastlake Park, the farm was founded by Francis Earnest and Joe Campbell in 1907, one year after Earnest opened the adjacent ostrich farm. Visitors to the farm could view the 1,000 alligators on exhibit and afterward purchase genuine alligator handbags, belts, and other products in the salesroom.

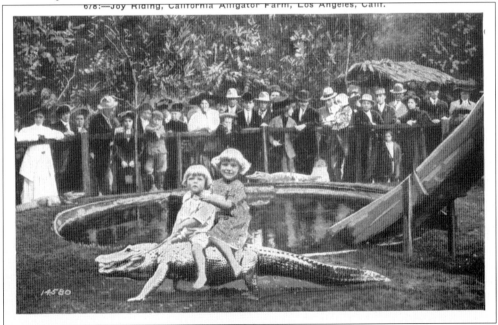

678:—Joy Riding, California Alligator Farm, Los Angeles, Calif.

Here two young children are shown riding on the back of an alligator, to the apparent delight of the spectators behind. Unlike in the previous image, this alligator does not have its mouth harnessed shut.

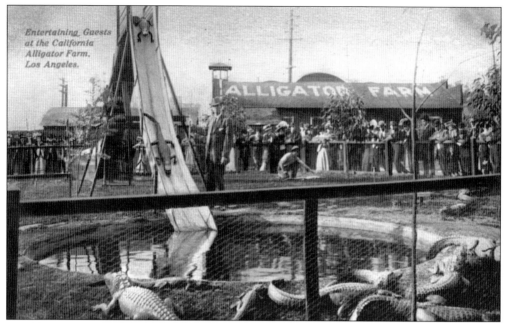

Entertaining Guests at the California Alligator Farm, Los Angeles.

In addition to explanations by guides about the life and habits of the alligator, visitors could enjoy a variety of alligator exhibitions. Trainers would demonstrate how an alligator was caught and would show them being hypnotized. In this view, spectators are watching on of the most popular shows: shooting the chutes. Trained alligators ascended a ramp to the top of the slide and then slipped down into the water below.

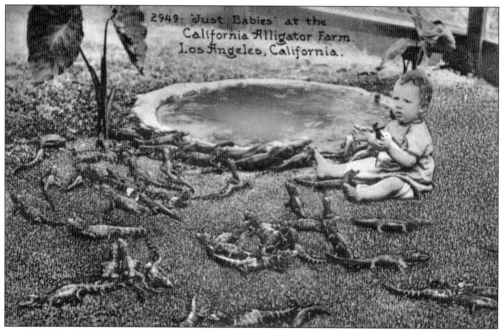

2949 "Just Babies" at the California Alligator Farm, Los Angeles, California.

This baby is enjoying playtime in the baby alligator pen. The park was arranged into a series of pens with miniature lakes, with the alligators separated by size. This separation was necessary as a result of the tendency of the larger alligators to eat the smaller ones.

Four

Downtown
Los Angeles

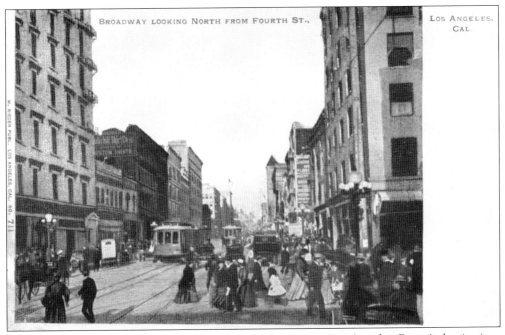

This postcard shows an early view of Broadway in downtown Los Angeles. From its beginnings as a small town, the city began to grow rapidly in the late 1800s. In a few decades' time, Los Angeles had become the largest city on the West Coast. Downtown Los Angeles, shown here when most buildings were only a few stories in height, would soon be filled with the finest department stores, hotels, restaurants, and theaters.

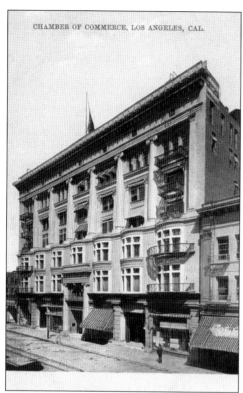

CHAMBER OF COMMERCE, LOS ANGELES, CAL.

Located on Broadway in the center of downtown, the Chamber of Commerce Building contained two floors of exhibits showcasing Southern California commerce and history. A popular tourist stop, the exhibits displayed everything from cases of California agricultural products to relics of the Spanish mission days.

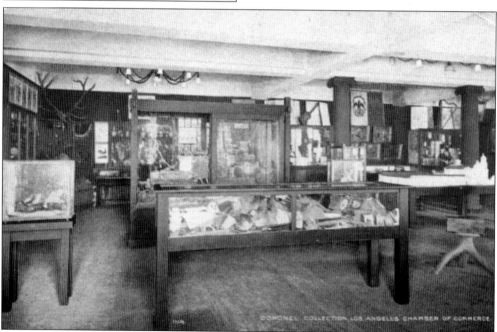

One of the exhibits in the Chamber of Commerce Building was the collection of Don Antonio Coronel, donated by his widow in 1901. On display were California Indian artifacts, relics from several California missions, Toltec artifacts from Mexico, and personal items of Don Coronel relating to life in early Southern California.

This view of Broadway and Seventh Street shows the growing business district, busy with streetcars and motorists even at night. On the right is the Orpheum Theater, constructed in 1911 for the Orpheum vaudeville circuit. This was the third Los Angeles home of the popular circuit, which featured some of the most well-known comedians and performers.

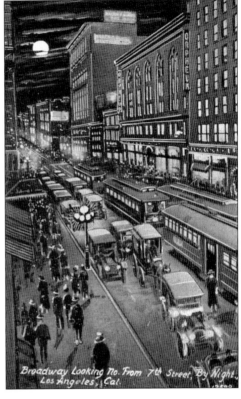

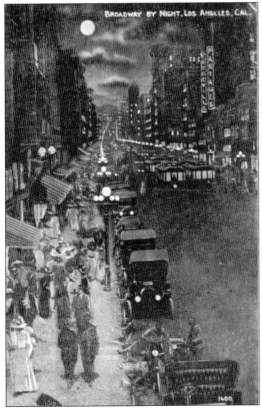

Here is another view of Broadway, between Fifth and Sixth Streets. Most early theaters in Los Angeles were found on Main Street; however, the theater district began to shift with the decision of the two most popular vaudeville circuits, the Pantages and the Orpheum, to construct theaters on Broadway. The Pantages Theater, seen at right, opened in 1911, the same year as the Orpheum Theater seen in the view above.

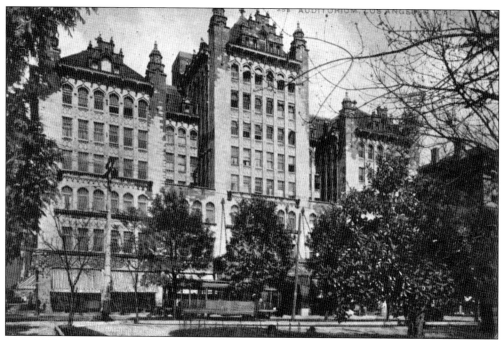

This 1907 postcard shows the Auditorium, located adjacent to Central Park at Olive and Fifth Streets. Dedicated on July 29, 1906, the new building replaced a recreational center known as Hazard's Pavilion. At the time of its dedication, it was the largest building in the world to have been constructed of steel and reinforced concrete.

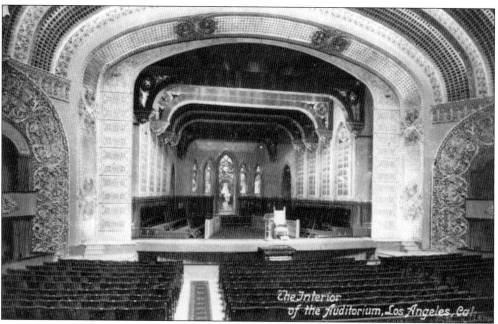

With a seating capacity of 4,000, the Auditorium was used to showcase operas, concerts, musical, movies, and other entertainment events. Beginning in 1920, it was leased to the Los Angeles Philharmonic Orchestra as the home of their winter productions. The Auditorium was also used by the Temple Baptist Church.

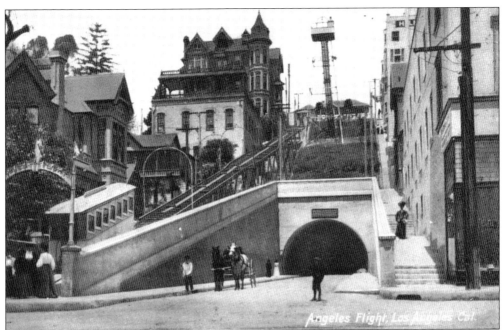

Angeles Flight, Los Angeles Cal.

This view shows the popular funicular railway Angels Flight, which ascended Third Street from Hill Street to Olive Street. Conceived by Col. James Eddy, the railroad opened in 1901, transporting passengers from the bustling shopping district to the neighborhood at the top of Bunker Hill. The two counterbalanced cars were named *Olivet* and *Sinai*, and a ride cost only 1¢ until 1914, when the fare was raised to 5¢. At the top of the hill is seen the 100-foot observation tower, from which visitors could enjoy a panoramic view of the city.

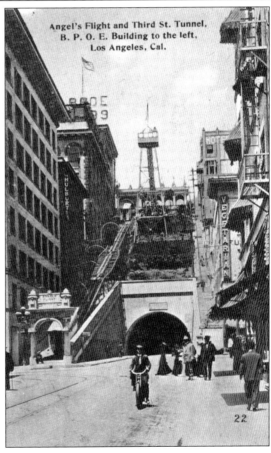

Angel's Flight and Third St. Tunnel, B. P. O. E. Building to the left, Los Angeles, Cal.

This later view of Angels Flight shows the results of Eddy's 1910 beautification efforts: a new colonnaded station house at the top of the incline and a new Beaux Arts archway at the Hill Street entrance. The letters B.P.O.E. were etched into the new arch when the Benevolent Order of Elks Lodge 99, who occupied the building at the top of the hill to the left of the station house, donated money to the project.

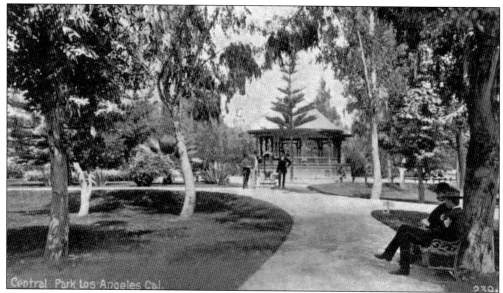

Central Park, the only park space in the downtown area, is located on the city block bounded by Fifth, Sixth, Hill, and Olive Streets. Although still a good distance from the central business district, the square was dedicated as a public park in 1866 by Mayor Cristóbal Aguilar. Initial landscaping efforts, carried out by citizens, consisted of random plantings. The first official layout for the park, designed by city engineer Fred Eaton in 1886, featured pathways meandering through grassy plots with a bandstand in the center.

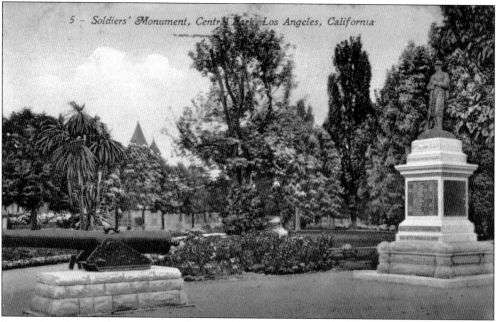

Located at the northeast corner of Central Park, the 20-foot granite statue seen here is a Spanish-American War memorial dedicated in 1900 to the 7th California Infantry. The bronze cannon was presented to the city by Maj. Gen. William Shafter, who captured it in 1898 in Cuba during the Spanish-American War. The cannon dates to 1751, when it was made for Louis XV of France.

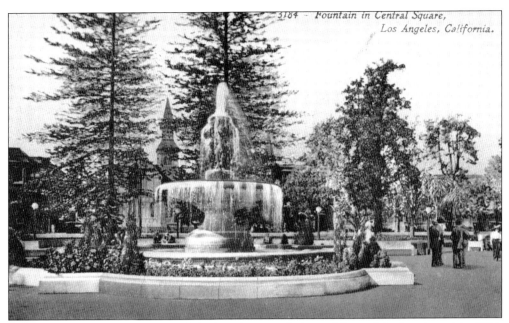

Postmarked in 1913, this postcard depicts the new design of Central Park, adopted in 1911. Following the plan of John Parkinson, the park was redone in a more formal fashion, with diagonal paths intersecting in the center of the square, where a large fountain was placed. Originally surrounded only with private residences, the park soon came to have a variety of churches, hotels, and other businesses as neighbors.

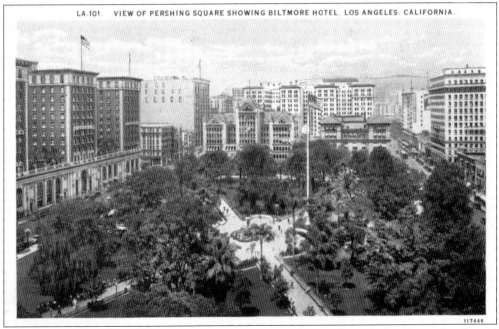

This overview of Central Park shows the 1911 design of the park, with the diagonal paths and central fountain. In 1918, the park was renamed Pershing Square in honor of World War I commander John J. Pershing. The Auditorium is visible at the far end of the park. The large building on the left is the Biltmore Hotel, constructed in 1923.

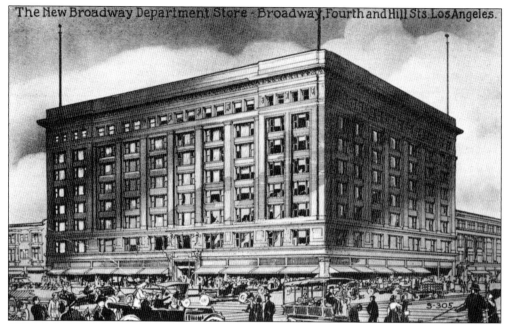

The Broadway, a popular department store, was located on Fourth Street between Broadway and Hill Street. Founded by Arthur Letts, the store building seen here was built in 1914 on the site of the original, smaller building that had been constructed with the store's founding in 1896.

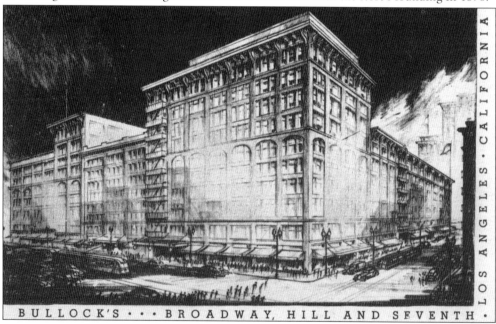

Located on Seventh Street between Broadway and Hill Street, Bullocks grew from its founding in 1907 to become one of the largest department stores in the West. The idea for Bullocks originated when Arthur Letts, owner of the Broadway, assigned top employee John Bullock to establish a new store aimed at a more affluent set of customers than those who patronized the Broadway. While Letts provided the start-up capital, Bullock, who later became the sole owner, was allowed to name the store after himself.

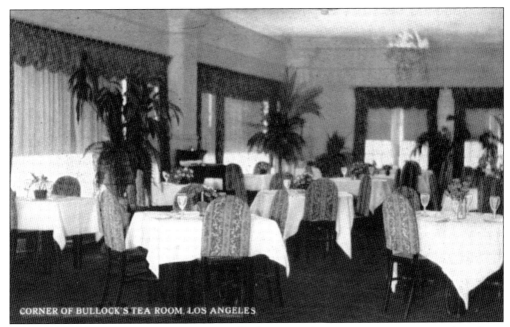

CORNER OF BULLOCK'S TEA ROOM, LOS ANGELES

Shown here is the Tea Room, located in Bullocks. Many department stores were not just places to shop; they also contained a variety of amenities for the convenience of their shoppers. Tea rooms, restaurants, parlors, and meeting halls were common.

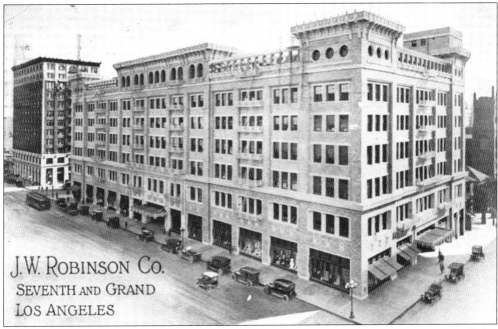

J.W. ROBINSON CO.
SEVENTH AND GRAND
LOS ANGELES

J. W. Robinson Company, shown here as a large department store, started out as a small dry goods store. Founded by J. W. Robinson in 1883, the store was originally located at Temple Street and Spring Street, moving to a variety of locations before settling on the block of Seventh Street between Grand Avenue and Hope Street in 1914.

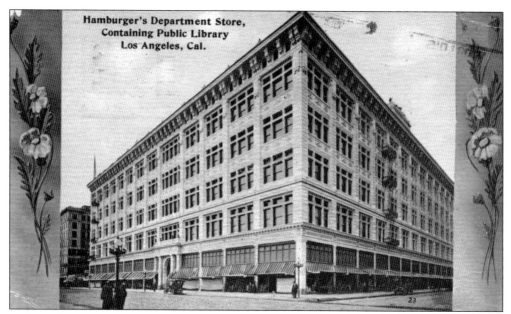

This 1913 postcard shows Hamburger's department store, advertised as being the largest and costliest in the West. Founded in 1881, the store moved several times before construction began in 1905 on the building depicted here. Situated on Eighth Street between Broadway and Hill Street, the new store was hugely popular. From 1908 to 1914, the building was also used to house the collections of the Los Angeles Public Library. The store was sold and renamed the May Company in 1929.

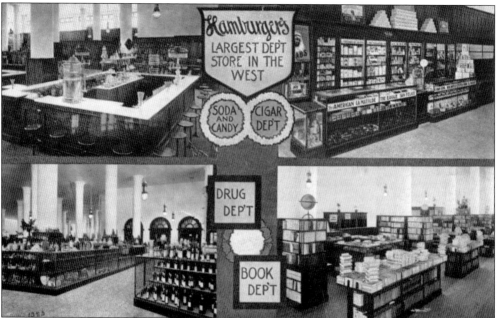

Shown here are some interior views of Hamburger's, known as the People's Store. One of the first to contain escalators, the store featured floors of shopping, a concert auditorium, parlors, reading rooms, dining rooms, and a rooftop garden. The store was so large it even had its own electric generators, as well as heating and refrigeration plants.

The Arcade Building, seen on the right, was a popular shopping destination located on Broadway between Fifth and Sixth Streets. The arcade on the ground floor went all the way through to Spring Street and was lined with shops. Adjacent to the Arcade Building is Dalton's Theater. Originally known as the Pantages, the theater was home of the Pantages vaudeville circuit from 1911 until they relocated to a new theater at Seventh and Hill Streets in 1920. Known as Dalton's for only eight years, the theater was renamed the Arcade in 1928. To the left of Dalton's is another theater, the Cameo.

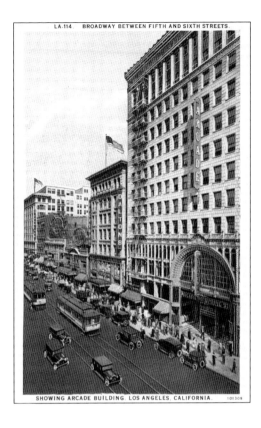

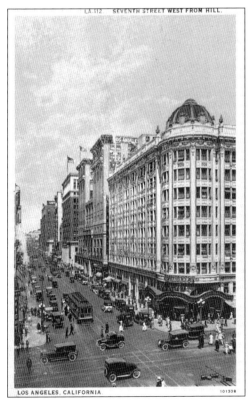

Opening in 1920, this theater at Seventh and Hill Streets was the new home of the Pantages vaudeville circuit. In 1929, the theater found a new use showing motion pictures when it was sold to the Warner Brothers Company and renamed the Warner Brothers Downtown.

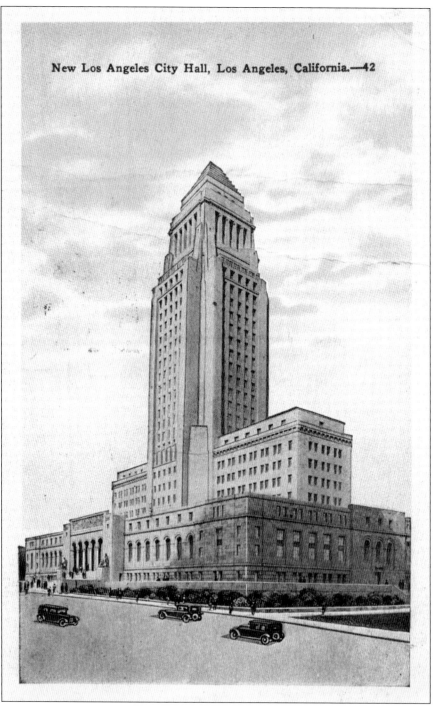

New Los Angeles City Hall, Los Angeles, California.—42

This 1928 postcard was written by a visitor who attended the dedication ceremonies of the new Los Angeles City Hall. An instant attraction because of its impressive height, the new building contained not only the city's administrative offices, but also an art gallery with changing exhibits by California artists. Guests could also visit the observation balcony on the 25th floor to enjoy a panoramic view of the city.

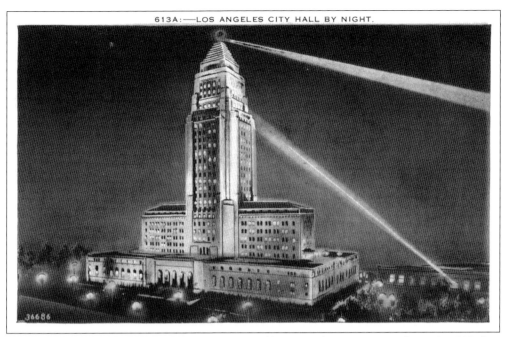

The city's first skyscraper, Los Angeles City Hall, received an exception from the 150-foot height limit in place at the time of its construction. Designed by Austin, Parkinson, and Martin, noted Los Angeles architects, the structure was completed in 1928 after two years of construction and a cost of $9 million. At 454 feet and 32 stories, it was for many years the most notable landmark, visible from all parts of the city.

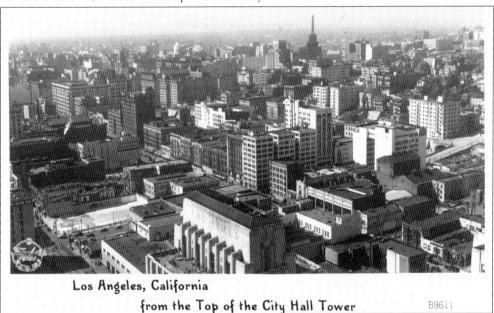

Los Angeles, California
from the Top of the City Hall Tower

At a time when all other buildings were limited to 13 stories, the new Los Angeles City Hall provided a superior view of the growing urban center. This real-photo postcard shows the impressive view to be had from the observation deck. The *Los Angeles Times* building, which opened in 1935 at First and Spring Streets, is seen in the foreground.

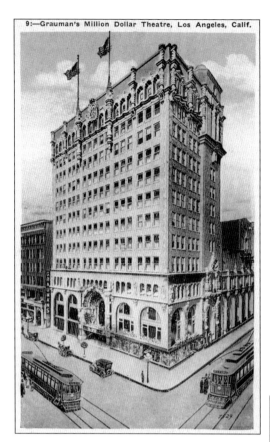

9:—Grauman's Million Dollar Theatre, Los Angeles, Calif.

The Million Dollar Theater, located at Broadway and Third Street, was constructed by Sid Grauman, who would later open the Egyptian and Chinese Theaters in Hollywood. The grand opening of the theater was held on February 1, 1918, with the premiere of *The Silent Man*, starring William S. Hart.

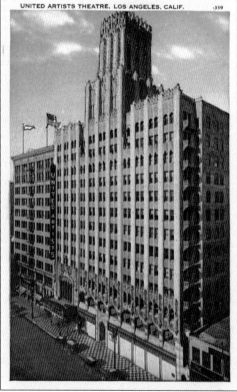

UNITED ARTISTS THEATRE, LOS ANGELES, CALIF. 359

The United Artists Theater opened on Broadway on December 26, 1927, with the premiere of *My Best Girl*, featuring Mary Pickford and Buddy Rogers. Seeking independence from the studios, the United Artists group was created in 1919 by D. W. Griffin, Mary Pickford, Douglas Fairbanks, and Charles Chaplin.

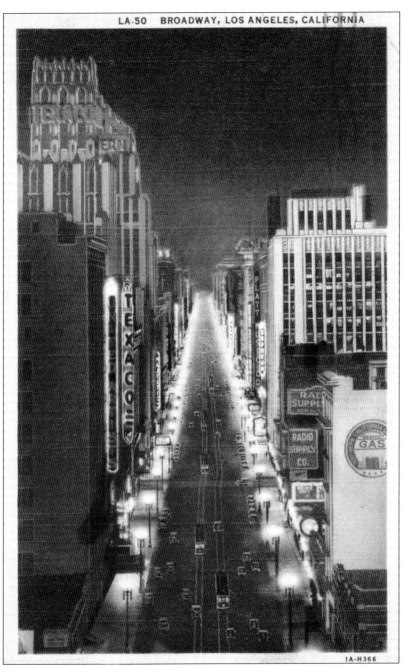

1A-H366

This view faces north along Broadway, showing the neon lights that were becoming a popular form of advertising. By the 1930s, Broadway was known not only for being home to some of the most popular department stores, but also for having the largest number of movie palaces in the country. One of these, the United Artists Theater, is seen on the left. Visible just past this is the sign for the Majestic Theater, which was used for both movies and live theater during the years it was open, from 1908 to 1929. On the right is the Orpheum Theater, built in 1926 as the fourth and final Los Angeles home of the Orpheum vaudeville circuit. In the early 1930s, the Orpheum, like many theaters in the area, became a movie theater.

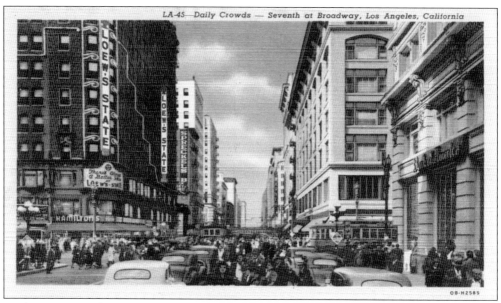

By the 1930s, cars had become a more common means of transportation, mixing with streetcars and pedestrians in this image to create a scene of traffic congestion. Broadway and Seventh Street was one of the busiest intersections, as many stores had begun locating along Seventh Street as the business district expanded. At left is Loew's State, opened in 1921 as the largest theater on Broadway.

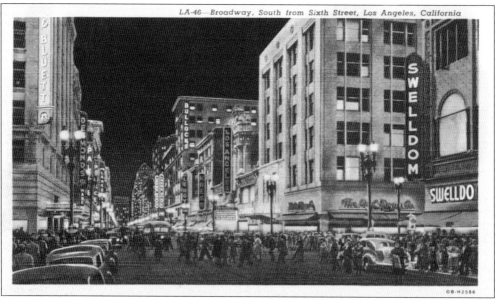

Shown here is a busy night scene at Broadway and Sixth Street. Many popular retailers are in view, including Swelldom and Bullocks on the right, and Mullen and Bluett and Desmond's on the left. Premiering in 1931, the Los Angeles Theater, on the right, was the last and most extravagant movie palace to be built on Broadway. On the left, just past Desmond's, is the Palace Theater. Opened in 1911 as the Orpheum, the theater was renamed the Palace and converted to a movie theater in 1926, when the Orpheum circuit moved to its newly constructed theater a few blocks away.

Five

CITY PARKS

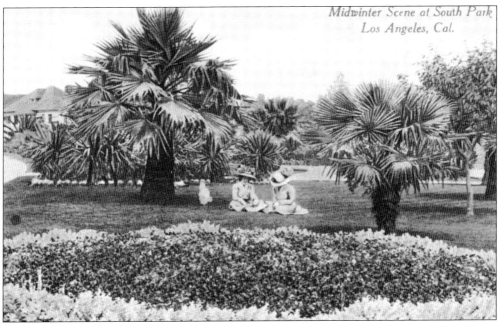

Pictured here is South Park, one of the many sizable parks in Los Angeles where visitors could enjoy the sunny climate in a scenic environment away from the bustle of the city. Located in the southern portion of the city, South Park featured picnic grounds, playgrounds, and horseshoe and tennis courts.

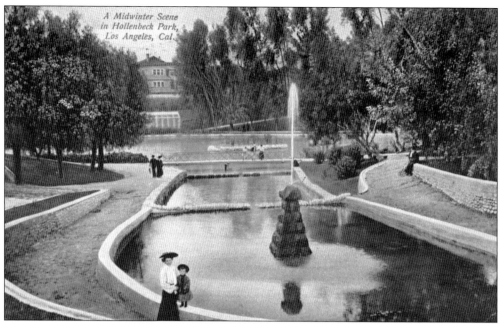

A Midwinter Scene in Hollenbeck Park, Los Angeles, Cal.

This 1910 postcard shows a view of Hollenbeck Park, a 26-acre park located near the Boyle Heights residential district east of downtown Los Angeles. William Workman and Elizabeth Hollenbeck donated the land for a park in the early 1890s. A modest and well-known pioneer citizen, Workman declined to have his name attached to the park.

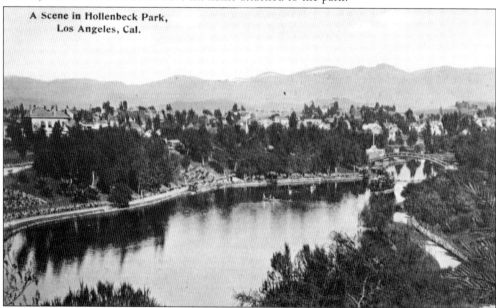

A Scene in Hollenbeck Park, Los Angeles, Cal.

Showing an overview of Hollenbeck Park and Lake, this postcard was postmarked in 1914. In addition to donating the land for the park, Elizabeth Hollenbeck gave 13 nearby acres to create the Hollenbeck Home, a residence for the elderly. She viewed these donations as a memorial to her husband, Edward Hollenbeck, who had been a prominent Los Angeles investor and banker. The Hollenbecks at one point owned more than 6,700 acres, much of it located in the Boyle Heights neighborhood.

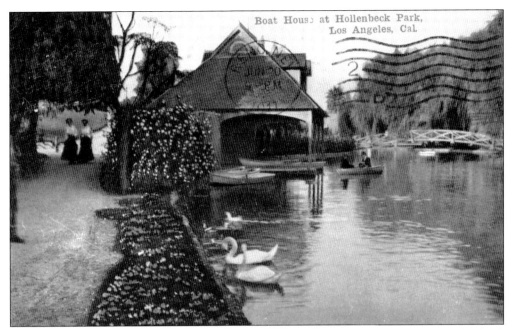

Boat House at Hollenbeck Park,
Los Angeles, Cal.

This image, postmarked in 1911, shows the boathouse located on the shores of Hollenbeck Lake. As at Echo Park, Eastlake Park, and Westlake Park, boating was a favorite weekend recreational activity. Other popular attractions at the park included picnic areas, playgrounds, Sunday concerts, and an aviary of beautiful birds.

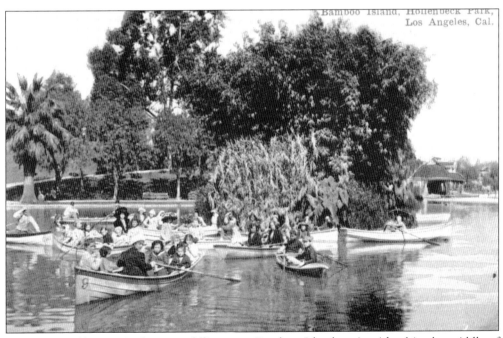

Bamboo Island, Hollenbeck Park,
Los Angeles, Cal.

This group of boaters is shown paddling near Bamboo Island, a tiny island in the middle of Hollenbeck Lake. The wood-frame boathouse is visible in the background on the right of the image.

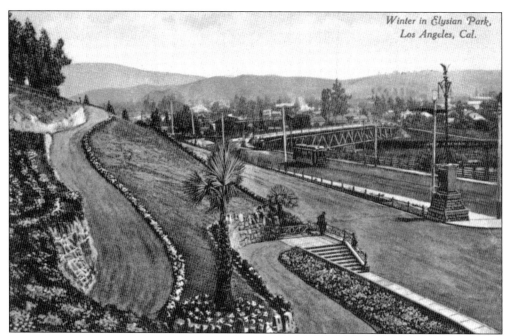

This view shows the Fremont Gate, located at the Broadway entrance to Elysian Park, the city's oldest and second largest park. The park is the last remaining large parcel of the original Spanish land grant that founded the pueblo of Los Angeles in 1781. In 1886, Mayor Edward Spence and the Los Angeles City Council dedicated the land as a city park, to be used for public purposes in perpetuity.

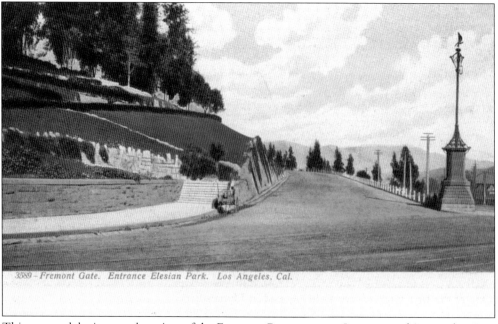

This postcard depicts another view of the Fremont Gate entrance. It was near this spot that Don Gaspar de Portola, leader of a Spanish exploring party heading north from Mexico, supposedly made camp in 1769.

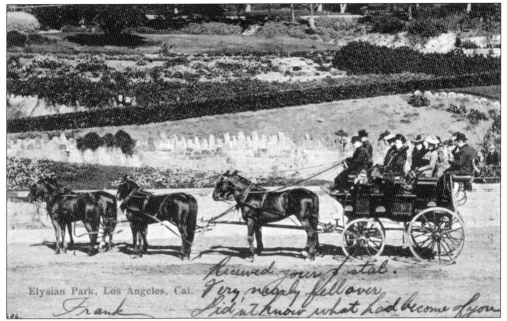

Originally known as the Rock Quarry Hills, the park was renamed Elysian Park upon dedication. The many hills and canyons of the park lands soon contained miles of scenic roads and foot trails, as well as a variety of landscaping. This 1900 postcard shows a team of horses carrying visitors over one of the new roads through Elysian Park.

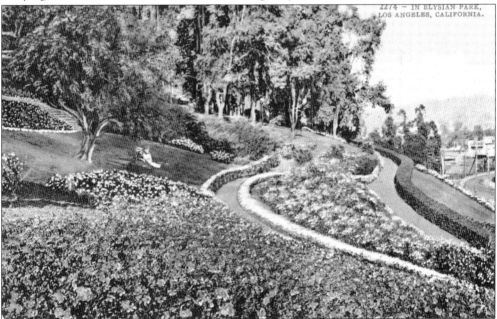

One of the first types of tree to be planted in Elysian Park was eucalyptus, chosen because it would grow quickly. Other varieties of trees and flowers began to be planted in 1893, when the Los Angeles Horticultural Society founded the Chavez Ravine Arboretum, the first botanical garden in Southern California. The rare date palms found on what is now Stadium Way were planted by the group in 1895.

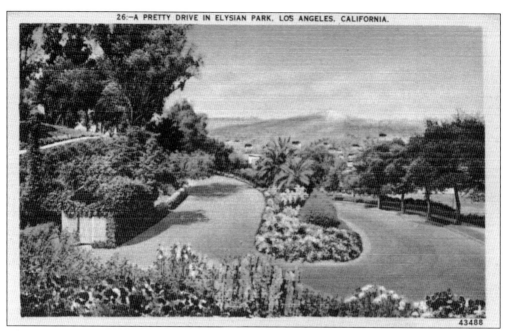

This view shows one of the winding scenic drives in Elysian Park, lined with flower beds and groves of trees planted by the horticultural society. Aside from date palms and eucalyptus, other types of trees planted in the park were rubber, olive, cedar, native walnut, and deciduous oak. In addition to the natural scenery, visitors could enjoy a panorama of the city from the top of some of the hills in the park.

This real-photo postcard shows visitors enjoying an afternoon among the rows of palms planted by the Chavez Ravine Arboretum. As a large nature reserve so near to the burgeoning city, the park was a popular spot for a picnic retreat. Elysian Park was also outfitted with tennis and horseshoe courts, hiking trails, and even a campsite in the earliest years.

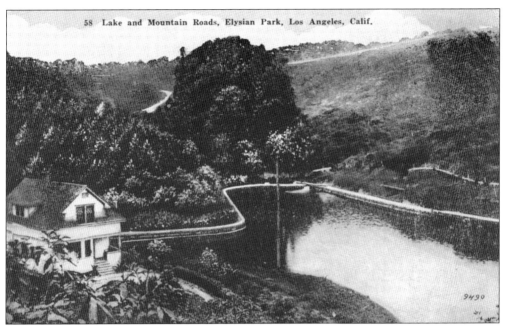

The Elysian Park Reservoir, shown here, was constructed in the Buena Vista Valley section of the park in 1903. Water from the city reservoir was used by arboretum members to water the flower beds and newly planted trees. While the reservoir appears to be part of a secluded mountain retreat, downtown Los Angeles is just over the hill.

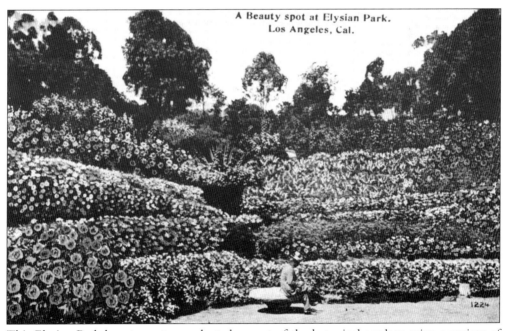

This Elysian Park beauty spot was planted as part of the botanical gardens using a variety of roses and other flowers. Originally watered using water from the reservoir, the plants were later watered by an irrigation system installed in the park in the 1930s.

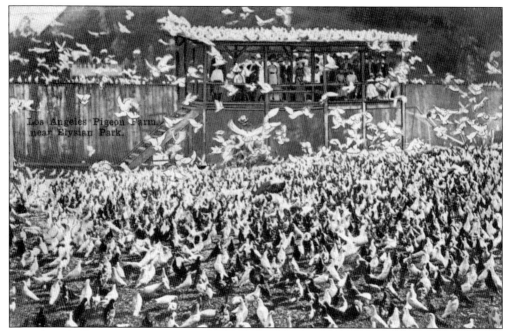

Ostrich and alligator farms were not the only animal parks in the Los Angeles area; there was also a pigeon ranch. Located adjacent to Elysian Park, the Pigeon Farm was the largest in the world. In this image, visitors can be seen observing the birds from an enclosed viewing deck.

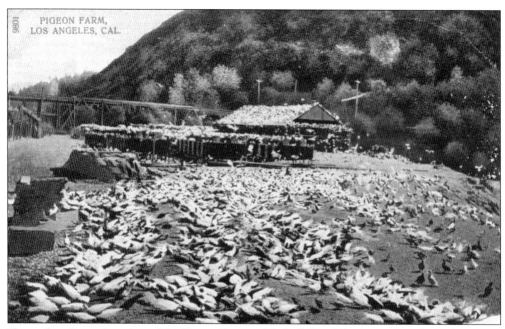

Shown here is another view of the Pigeon Farm, with the hills of Elysian Park in the background. Visible also are the elevated railroad tracks. Grain was often accidentally dropped from the trains that passed by on their way to make deliveries downtown, providing some of the food for the pigeons, which were known to consume up to 60 bushels of grain a day.

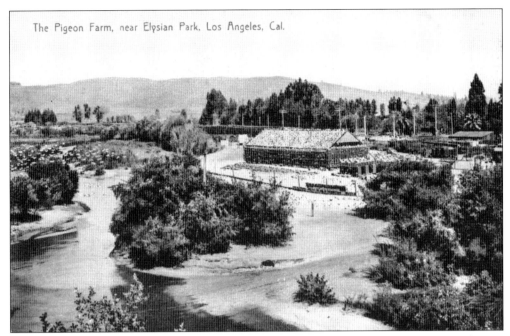

The Pigeon Farm, near Elysian Park, Los Angeles, Cal.

The Los Angeles River, at left, ran alongside the Pigeon Farm, providing a source of water for the free-flying birds. However, in the late 1930s, a storm flooded the river and washed the ranch away. It was never rebuilt.

SYCAMORE GROVE, LOS ANGELES, CAL.

Sycamore Grove, a 20-acre park located in the Highland Park neighborhood of Los Angeles, was named after the several hundred sycamores that grow there. The park was a popular place to hold large state picnics and other club gatherings, sometimes hosting groups numbering in the thousands.

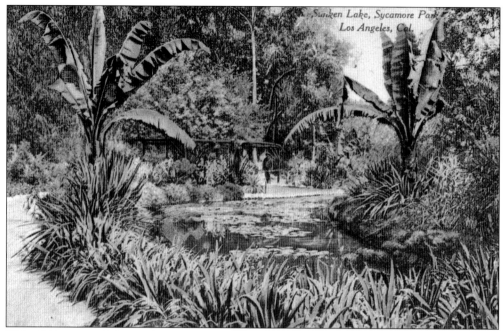

This 1912 postcard shows the small lily pond found in Sycamore Grove Park. Popular as a recreation area since the 1860s, the city of Los Angeles formally added the area to its park system when it purchased a portion of the park in 1905. The rest of the land that came to compose the park site was donated by E. R. Brainerd two years later.

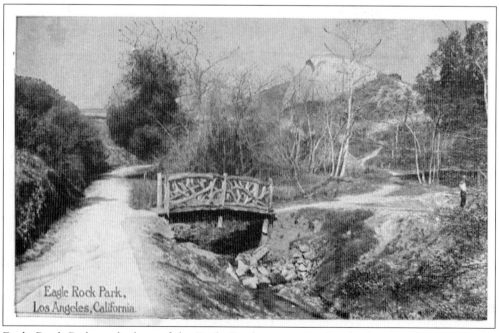

Eagle Rock Park, at the base of the Eagle Rock, was a popular site for church picnics and a variety of other social gatherings. The location also served on several occasions as the site of Easter sunrise services.

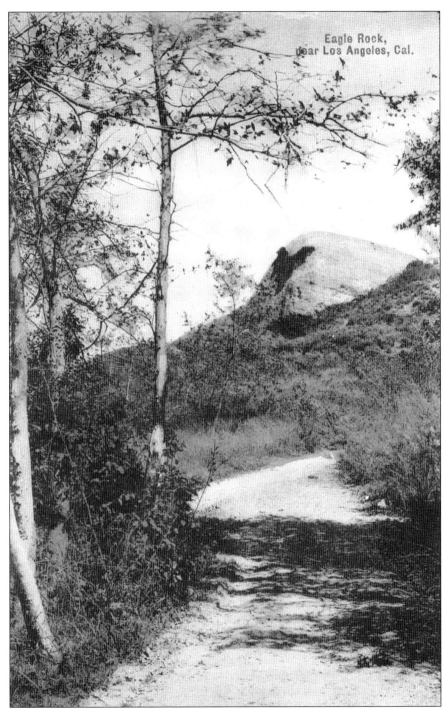

Eagle Rock,
near Los Angeles, Cal.

This 1907 postcard shows a view of the Eagle Rock, one of the most unusual natural formations in Los Angeles County. Located in the Eagle Rock neighborhood between Glendale and Pasadena, Eagle Rock Park was visited by many tourists who would stop to view the large rock outcropping. Best seen when shadows play off the rock, the eagle, appearing with outspread wings, is formed by an eroded overhang.

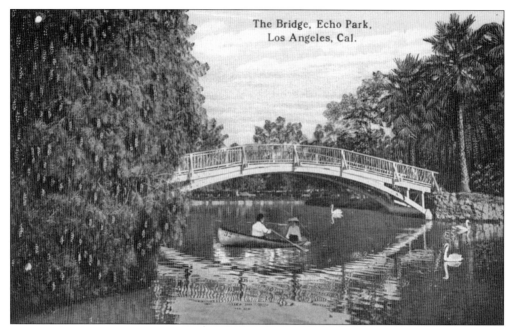

The Bridge, Echo Park,
Los Angeles, Cal.

Echo Park Lake originated in the 1870s, when city-owned Reservoir No. 4 was constructed. The idea for a park formed when Thomas Kelley and other owners of property adjacent to the lake discovered that their land was useless because of an ordinance allowing the city to overflow the reservoir should they see fit. The property owners and the city soon reached a deal, by which the city agreed to never overflow the reservoir, in return for a donation of 30 acres to be used for a park. With the city providing landscaping and a boathouse, the new park was dedicated in 1895. Located in close proximity to the city center, Echo Park quickly became a popular refuge for visitors to enjoy a picnic, boat ride, or a scenic lakeside stroll. The park contained two attractive bridges, one over the northwest corner where lotus beds grew and another connecting to a small island.

Palm Walk
in Echo Park,
Los Angeles, Cal.

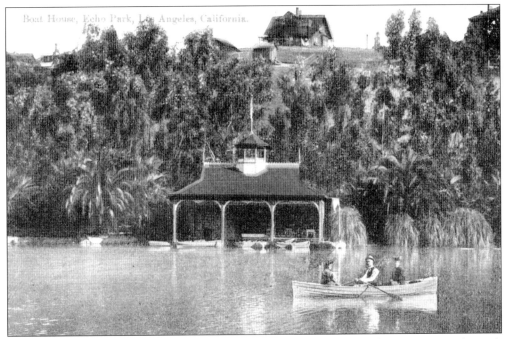

Shown here is the original wood-frame boathouse on Echo Park Lake. Visitors to the park could rent wooden canoes and spend an afternoon paddling on the lake. This boathouse was used from 1895, when the park opened, until the 1930s, when it was replaced.

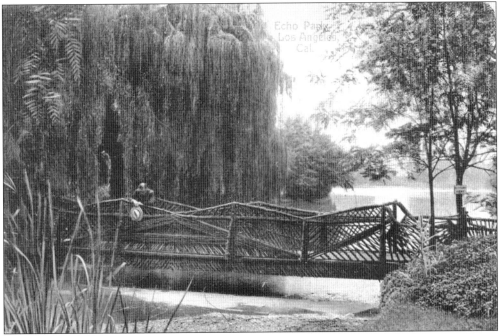

Superintendent of Parks Joseph Henry Tomlinson, appointed in 1899, decided to landscape Echo Park in a rustic English-garden style. Built of twigs in a fashion popular at the time, this rustic bridge was part of a landscape meant to lend the park the feel of a country-style refuge.

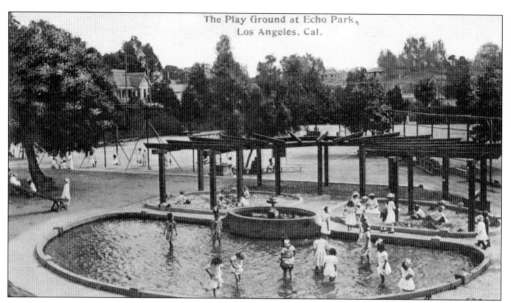

Beginning in 1899, the city began expanding Echo Park by adding a variety of playing fields and tennis courts. The Echo Park Playground, adjacent to Echo Park, opened in May 1907 as the second children's recreation center in the city. The founding of the Playground and Recreation Department in 1904 made Los Angeles the first in the nation to have a recreation department separate from a parks department. The first president of the department, Mrs. Willoughby Rodman, was central in the establishment of the first public playgrounds in the city. A clubhouse was added to the Echo Park Playground a year after its opening.

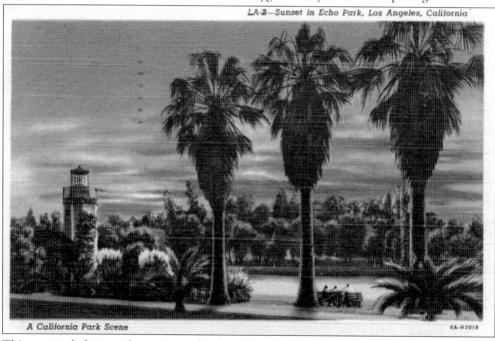

LA-2—Sunset in Echo Park, Los Angeles, California

A California Park Scene 6A-H3018

This postcard shows a later view of Echo Park. Visible on the left is the new boathouse that succeeded the original wood-frame structure. Completed in 1932, the boathouse was constructed in Spanish mission style and featured a lighthouse with a functional beacon.

Six

EXPOSITION PARK

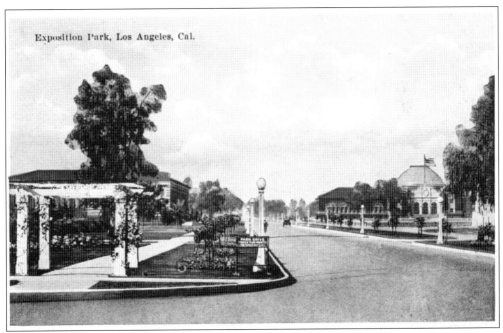

Exposition Park, Los Angeles, Cal.

This postcard shows an entrance to Exposition Park, a 130-acre public park containing a museum, exposition building, armory, rose garden, and the Coliseum. Exposition Park occupies a site once known as Agricultural Park, which had originally been used as a fairground and for agricultural displays. However, by the 1890s, the site had become disreputable, home to horse racing and gambling. A citizen coalition led by William Bowen finally won their case to clean up the park in 1908. The city, county, and state agreed to each make a contribution and jointly maintain the new park, which was officially opened to the public in 1910.

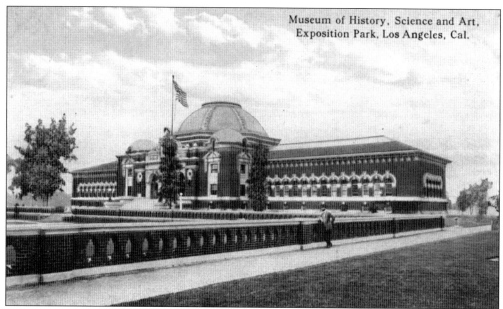

The Museum of History, Science, and Art opened in November 1913 under the operation of the County of Los Angeles. Exhibits in the museum displayed everything from fossils to paintings and articles pertaining to early California history. There was also an anthropology room, a display of early machinery, and a motion picture exhibit. The building was subsequently enlarged numerous times, as the museum's collection quickly outgrew the original structure.

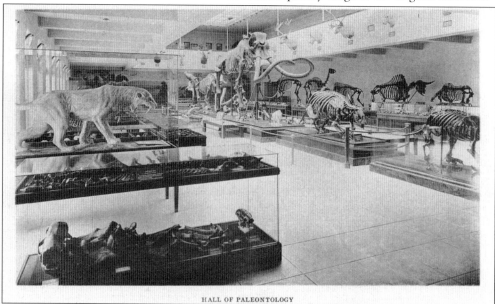

HALL OF PALEONTOLOGY

This view shows the Hall of Paleontology at the Museum of History, Science, and Art. This hall displayed one of the largest collections of Pleistocene-period fossils, which had been dug from the nearby La Brea Tar Pits. Skeletons of animals such as imperial elephants, giant sloths, and saber-toothed tigers were excavated beginning in 1906 by Los Angeles High School and Occidental College students. The County of Los Angeles assumed control of dig operations in 1913.

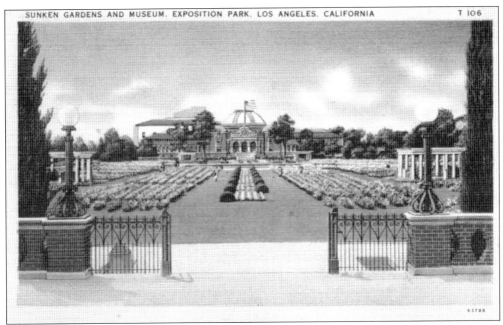

This postcard shows the 7-acre sunken rose garden, with the museum behind. Planted and maintained by the Los Angeles City Parks Department, the rose garden contained over 15,000 rosebushes of over 100 varieties. A water lily pool is located in the center, and four white stone pergolas are seen near the corners of the garden.

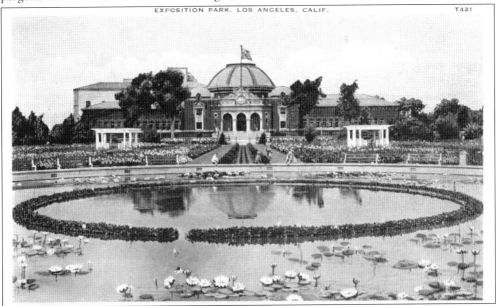

The water lily pool, located in the center of the rose garden, was constructed to celebrate the opening of the Owens Valley Aqueduct, which brought water to Los Angeles from the Sierra Nevadas over 200 miles away. The dedication of the fountain site took place on November 6, 1913, the day after the official opening of the aqueduct. The celebration at Exposition Park that day also included the grand opening of the museum and cornerstone-laying ceremony at the armory.

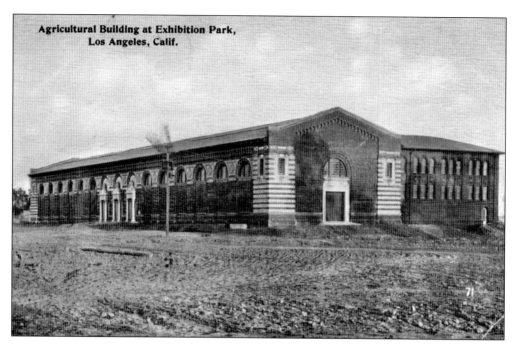

Agricultural Building at Exhibition Park,
Los Angeles, Calif.

The State Exposition Building was constructed by the State of California in 1913 to display agricultural products and examples of other state assets. The above image shows a very early view of the building, probably just following completion, as the surrounding area has not yet been landscaped. The image below shows the building as it appeared after the grounds have been landscaped. The two-story E-shaped brick building was located to the south of the rose garden. The west wing contained horticultural exhibits, the southwest wing was dedicated to animal industries, and the east hall housed the mining division. The basement contained exhibits showcasing state park facilities.

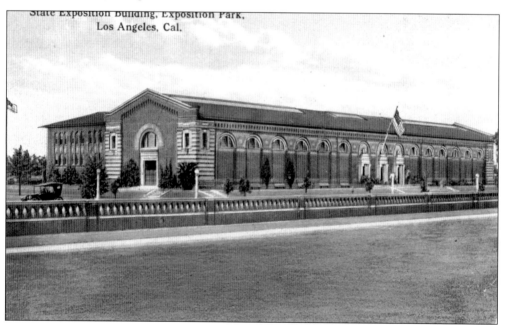

State Exposition Building, Exposition Park,
Los Angeles, Cal.

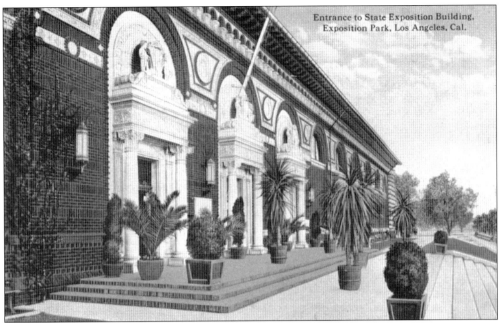

This view is of the entrance to the State Exposition Building, showing the terra-cotta ornamentation. Upon entering the building, visitors would find a main hallway lit by a four-panel stained-glass ceiling portraying historical California structures. On exhibit inside were examples, photographs, and models of state resources and industries, including minerals, manufactured products, ranching, movie making, oil drilling, agriculture, and scenes from each county in the state.

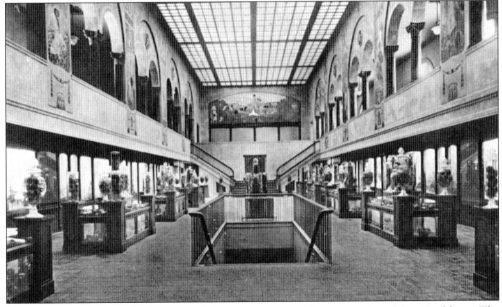

This postcard depicts the interior of the west wing of the State Exposition Building. The caption on the card explains that the wing included "valuable information on methods and localities of production covering all commercial horticultural crops of the State. The large rural painting at the end of the room is entitled 'The Spirit of Progress in California'."

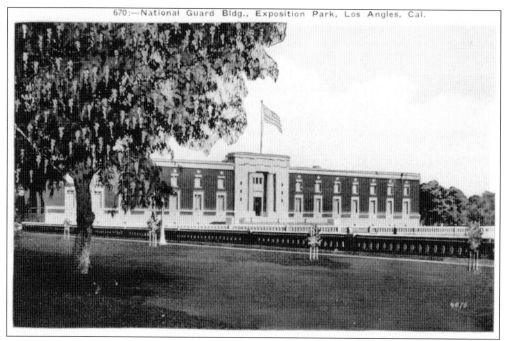

The Armory, constructed in 1913 and opened for use in 1914, was constructed to serve as the headquarters of the California National Guard. The building contained offices, barracks, and supply rooms. Visitors could observe as the National Guard marched and drilled outside.

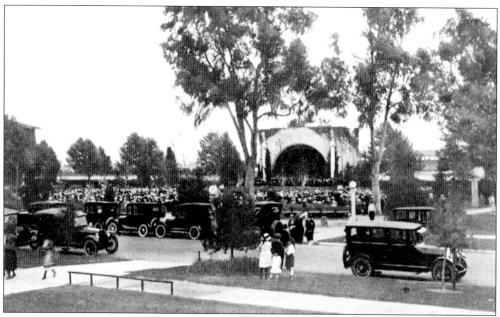

Shown here is the bandstand on the grounds of Exposition Park. With seating for 5,000, the bandstand programming allowed visitors to enjoy concerts and other entertainment events. The grounds of the park, maintained by the Los Angeles City Parks Department, also contained bowling greens, tennis courts, a clubhouse, and other recreational facilities.

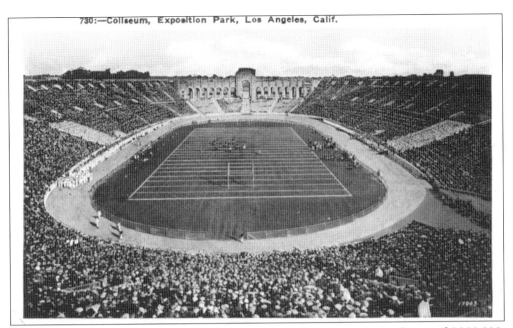

The Coliseum was opened in 1923 after two years of construction and cost of $800,000. Seating more than 70,000 people, the Coliseum was designed by John and Donald Parkinson, the same architects who helped design such landmarks as Bullocks Wilshire, Union Station, and Los Angeles City Hall.

The Coliseum, Los Angeles, California.

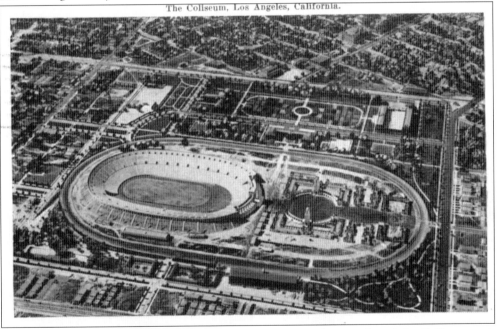

This 1925 postcard shows an overview of the Exposition Park grounds and the Coliseum as it originally appeared. The Coliseum's 55-acre playing field has been used by the neighboring University of Southern California for their football games since 1923, as well as by other schools, teams, and groups for a variety of events. Beginning in 1928, the Coliseum underwent remodeling to increase seating capacity in order to accommodate the 1932 Olympics.

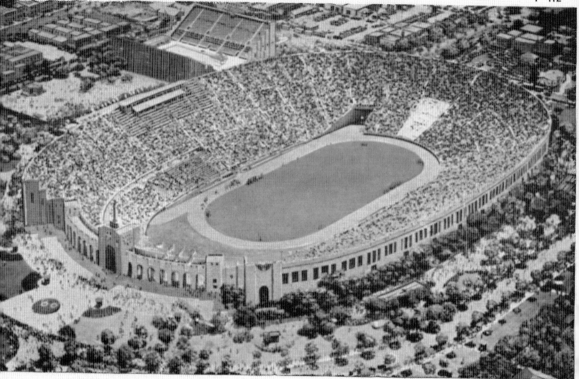

The 1932 Summer Olympics were held at the enlarged Coliseum, now seating 105,000. Funded by a State Olympiad Bond Act, the enlargement cost almost the same as the original construction cost. At the top of the image is the 5,000-seat Swimming Stadium, which was designed to host the Olympic aquatic events.

Seven

HOLLYWOOD

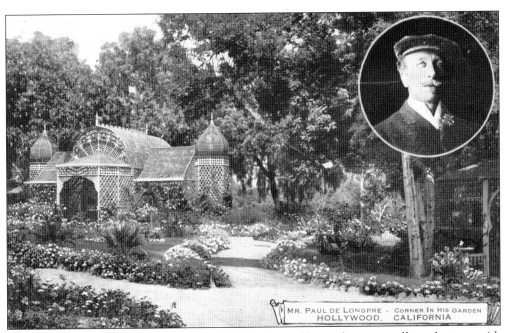

MR. PAUL DE LONGPRE - CORNER IN HIS GARDEN
HOLLYWOOD, CALIFORNIA

Before the arrival of the first movie studio in 1911, Hollywood was a small rural town, with homes surrounded by orchards and flower fields. One of the first attractions in Hollywood was the home and gardens of Paul de Longpre, a renowned floral painter. His residence, built in 1901, occupied three acres at Prospect Avenue, later renamed Hollywood Boulevard, and Cahuenga Avenue. Visitors were allowed to tour his Moorish-style home and his flower gardens, from which he gathered subjects for his popular paintings.

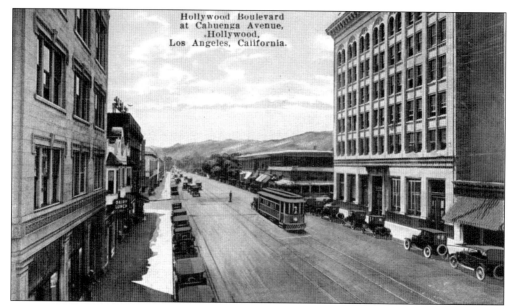

Here is a view of Hollywood Boulevard after Hollywood had ceased to be a small rural town. Between the dawn of the 20th century and 1930, Hollywood's population skyrocketed from 500 to 157,000, mostly thanks to the arrival of the movie studios. The first studio was established at Sunset Boulevard and Gower Street in 1911 by the Nestor Film Company. Other studios soon followed, attracted by the predictable weather and the variety of landscapes to be found within a short drive of the city.

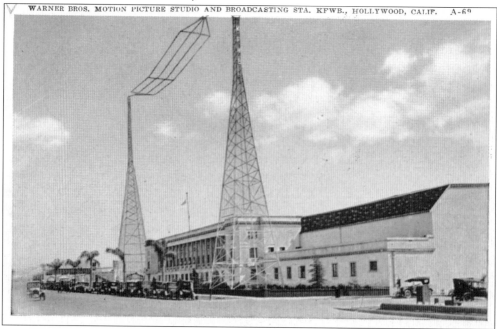

Considered a leader in the movie industry, Warner Brothers Studio constructed this studio on Sunset Boulevard in the 1920s. The grounds contained huge backlot stages as well as their administrative offices. This building was also used to broadcast their radio station KFWB, founded by Warner Brothers in 1925 as a way to help publicize upcoming releases.

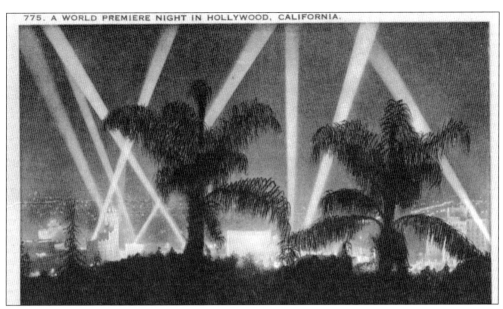

Shown here are the bright lights of Hollywood Boulevard advertising a movie premiere. Visitors flocked to Hollywood from all over the country in hopes of catching a glimpse of their favorite star. At the glamorous premiere events, fans would gather near the theater, hoping for an autograph. During the day, they would shop where the stars shopped, at the many exclusive stores that had begun locating on Hollywood Boulevard as the city's fame grew. A lucky visitor might even catch a peek into the movie world when a street, bank, or other location was roped off for a movie shoot.

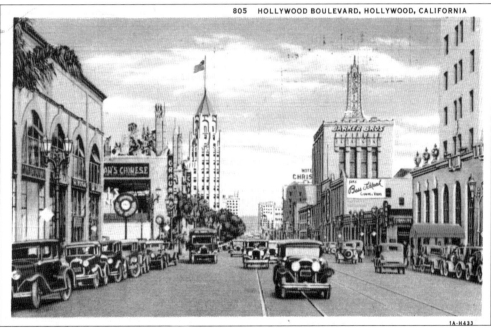

805 HOLLYWOOD BOULEVARD, HOLLYWOOD, CALIFORNIA

This postcard shows the 1930s skyline of Hollywood. Several movie palaces were built on Hollywood Boulevard in the 1920s, including the Chinese Theater, visible on the left. The tall building on the right contained the El Capitan, a live performance theater opened in 1926.

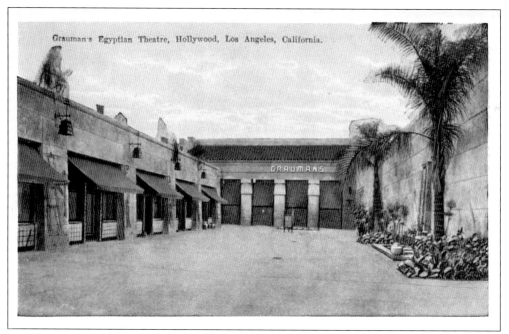

Seen here is the forecourt and entrance of the Egyptian Theater, the first movie palace on Hollywood Boulevard. Built by Sid Grauman, the theater opened in 1922 with the premiere of *Robin Hood*, starring Douglas Fairbanks. Designed to resemble an Egyptian temple, the auditorium featured carved columns and sphinxes.

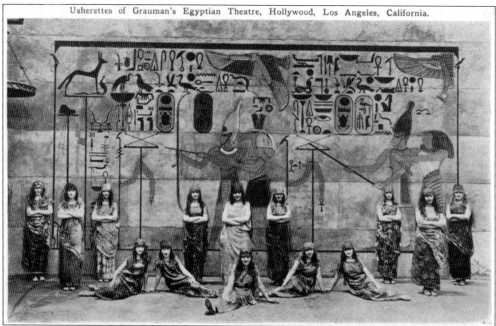

This view shows the usherettes of the Egyptian Theater posing in front of one of the Egyptian-style murals that decorated the forecourt of the theater. The left side of the forecourt was lined with shops selling Oriental-style products, feeding off the fascination with anything Egyptian that had begun with the discovery of the tomb of King Tutankhamen in 1922.

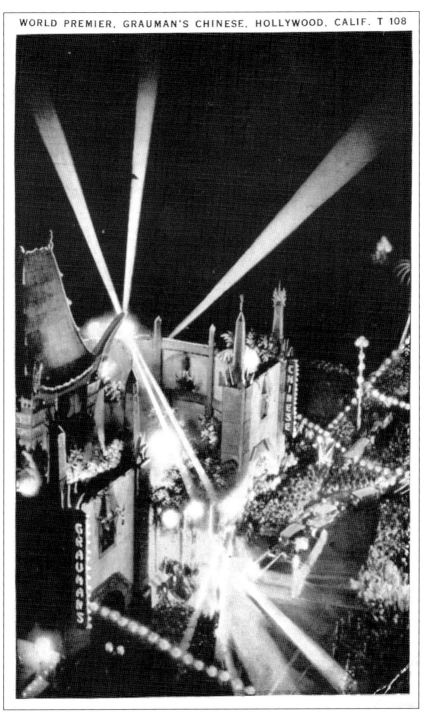

The Chinese Theater, built by Sid Grauman in 1927, was one of the most popular theaters for movie premieres. The second movie palace to be constructed in Hollywood, the Chinese held its grand opening with the premiere of Cecil B. DeMille's *King of Kings*. Mary Pickford, Douglas Fairbanks, and Norma Talmadge were the first in the soon to be long list of celebrities who have placed imprints of their hands and feet in the cement of the theater's forecourt.

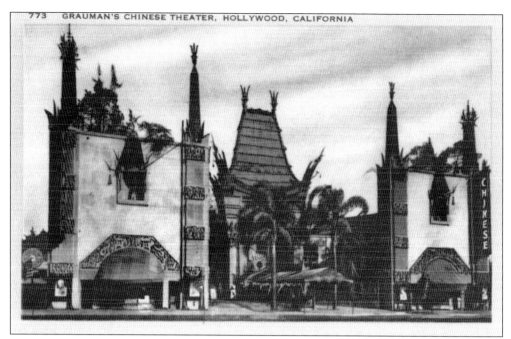

Running on the success of the Egyptian Theater, Sid Grauman designed the Chinese Theater in the style of a Chinese temple. Grauman imported a variety of Chinese art and artifacts to be used for theater decorations, including temple bells, obelisks, and a pagoda.

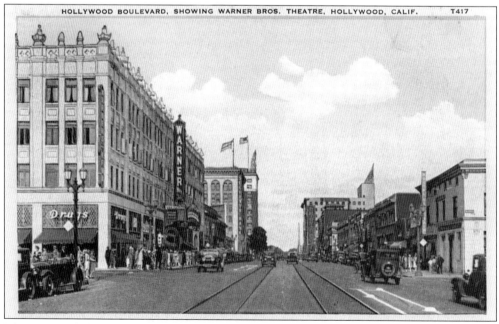

HOLLYWOOD BOULEVARD, SHOWING WARNER BROS. THEATRE, HOLLYWOOD, CALIF. T417

This postcard shows the intersection of Hollywood Boulevard and Wilcox Avenue, with the Warner Brothers Theater on the left. The theater opened April 28, 1928, as the third movie palace to be located on Hollywood Boulevard. Only one other movie palace would be constructed on Hollywood Boulevard: the Pantages, which opened in 1930 as the largest and most ornate of the four.

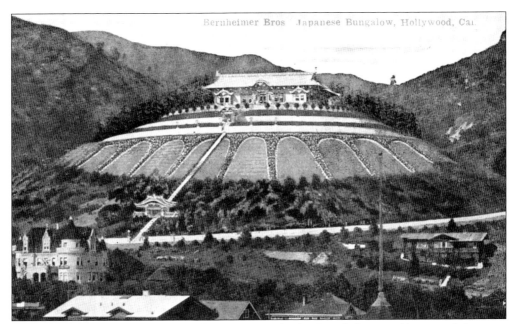

Built by Adolph and Eugene Bernheimer in 1914, the Bernheimer residence and Japanese gardens were located on a hill overlooking Hollywood. Visible in the image are the 300 steps that led up to the mansion, a replica of a Japanese palace. The large home in the lower left corner, currently known as the Magic Castle, was constructed in 1908 by banker and real estate investor Rollin Lane.

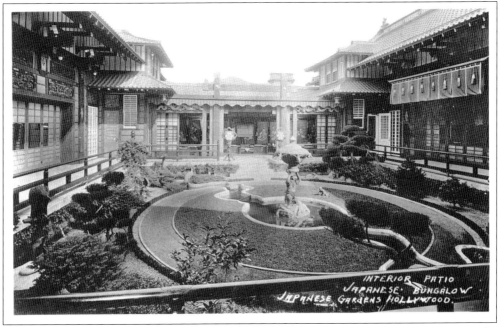

This real-photo postcard shows the interior patio courtyard of the Bernheimer mansion. The rooms surrounding the courtyard contained the brothers' priceless collection of Asian art and antiques. The patio garden was landscaped in traditional Japanese style, as were the rest of the grounds. The pool, visible at center, was populated by rare fish.

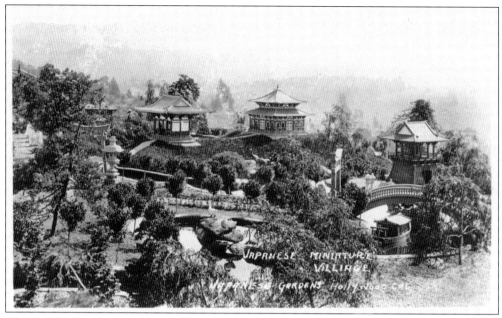

This miniature village was a part of the vast landscaping project carried out by the Bernheimer brothers. The grounds also contained a Japanese shrine, a waterfall, hillside terraces, and a 600-year-old pagoda. For a small entrance fee, visitors could explore the gardens and enjoy the panoramic view of Hollywood.

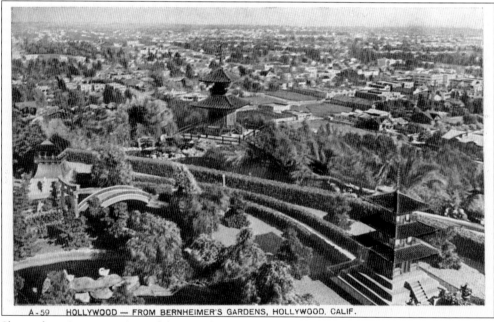

Shown here is an overview of the Bernheimer gardens, with the growing city of Hollywood below. Following the death of Eugene, Adolph sold the property in 1923 and auctioned off the collection of Asian art and antiques. After many years of disrepair, the estate and gardens were eventually restored and are now home to Yamashiro, a well-known restaurant.

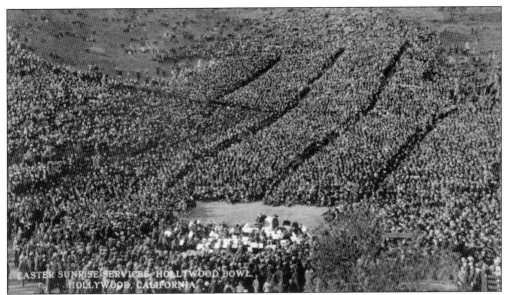

One of Southern California's most popular outdoor venues, the Hollywood Bowl is shown here in its earliest days, before seating and a stage were installed. The site was purchased in 1919 by the Theater Arts Alliance, who planned to present a variety of outdoor theatrical performances. Originally known as Daisy Dell, the location was chosen for its natural acoustics. In 1924, the site came under the ownership of the county of Los Angeles and has since been managed by the Hollywood Bowl Association.

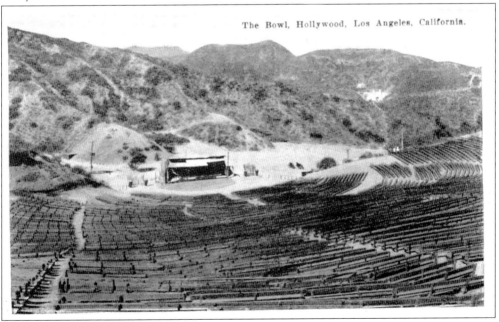

Shown here is the Hollywood Bowl as it appeared in the early 1920s, with a small canopied stage and rows of wooden seats. The tradition of Easter sunrise services began at the bowl in 1921, the same year the first concerts were held. The summer concerts proved so popular that the season was extended, with the series receiving the name "Symphonies Under the Stars" in 1923.

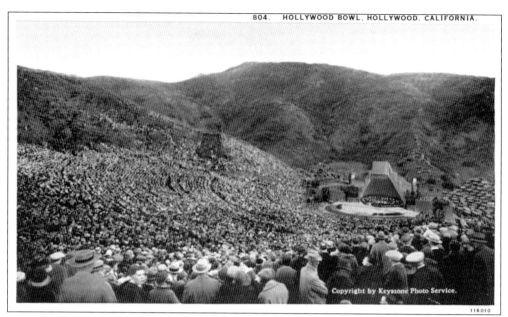

Copyright by Keystone Photo Service.

116010

One of the first shells to be constructed over the Hollywood Bowl stage was this pyramid-shaped shell, built by Lloyd Wright Jr. in 1927. The shell was removed after only one season because of complaints about its unattractiveness. In 1929, a new design was approved, and a new steel shell composed of concentric circles was constructed. Also in the 1920s, new seating was installed, increasing capacity to 20,000.

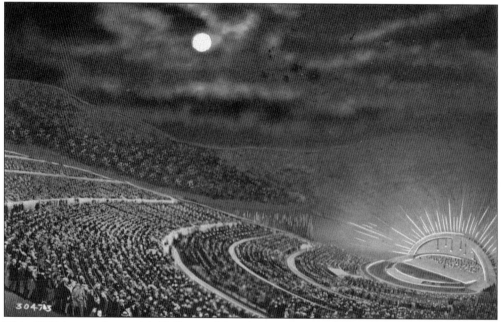

This 1932 image shows the Hollywood Bowl at night, with visitors attending the famous "Symphonies Under the Stars" concert series. Appearing at the bowl were a variety of performance types, including operas, pageants, orchestras, and ballets. The Los Angeles Philharmonic Orchestra, founded by William Clark Jr., performed there as their summer home, while the Auditorium in downtown Los Angeles served as their winter home.

Eight

GRIFFITH PARK

Auto Road, Griffith Park, Los Angeles, Calif.

On December 16, 1896, Col. Griffith J. Griffith donated over 3,000 acres of land to the City of Los Angeles for use as a park. Because it was mostly mountainous and located outside the city limits, the new park lay inaccessible and mostly unused for several years. Finally, at Griffith's urging, a few automobile roads, trails, and other developments began to occur in the park. When the park was incorporated into the city of Los Angeles in 1910, interest in the park began to increase. By the 1930s, Griffith Park had become a popular retreat with thousands of visitors and a wide variety of amusements.

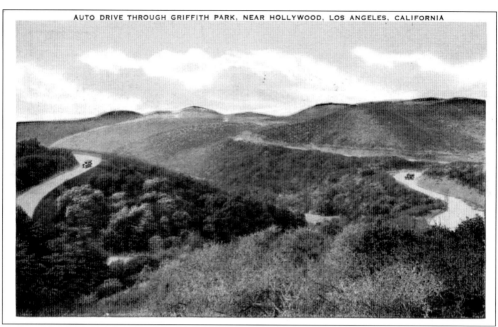

Most city parks in the early 1900s were developed in the style fashionable at the time, with landscaped lawns and flower beds for strollers and picnickers to enjoy. As this was not feasible in Griffith Park because of its size and geography, most of the park was left in its natural state, with only a few roads and trails passing through. Under the direction of Griffith's son, Van, the various plantings that occurred in the 1920s in the mountainous areas of the park focused on native vegetation.

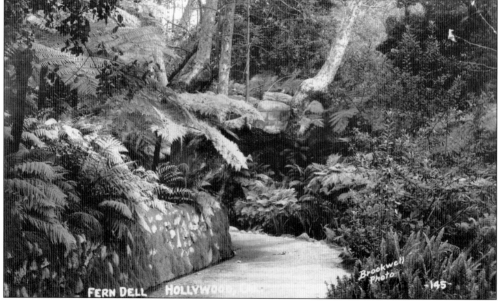

This real-photo postcard shows Fern Dell, located near the Hollywood entrance at Western Avenue. Hundreds of ferns, including varieties from all over the world, were found there, lining a small brook. The dell was a favorite spot for visitors, who enjoyed walking among the rustic scenery.

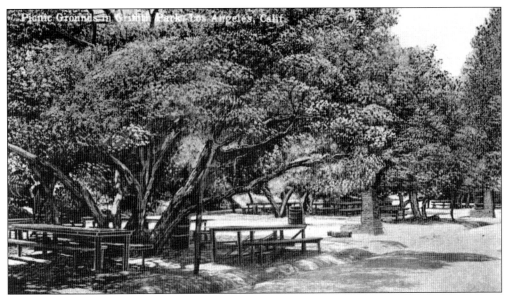

Shown here is one of the picnic grounds found at Griffith Park. By the 1930s, there were numerous such spots, mostly located on the few flat stretches of park land at the base of the hills. Other amusement facilities in the lower part of the park included tennis courts, golf courses, playgrounds, baseball diamonds, and a municipal swimming pool. The Los Angeles Zoo was another attraction, established in the park a short distance from its current location when the animals from the closed Eastlake Park Zoo arrived in 1913.

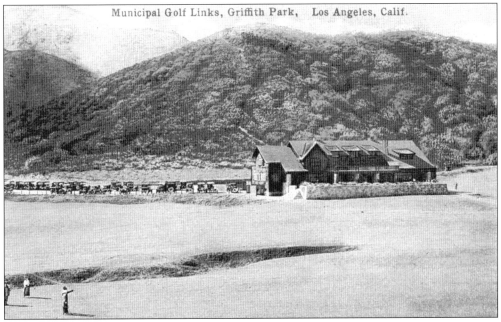

In 1922, the second municipal golf course, pictured here, opened in Griffith Park. Later renamed after Woodrow Wilson, the course was a significant improvement over the dirt field of the earlier Riverside Course, which was soon closed for renovations. The newly redone course, now named after Warren Harding, opened in 1924. A third, smaller golf course, the Roosevelt Course, opened in 1937.

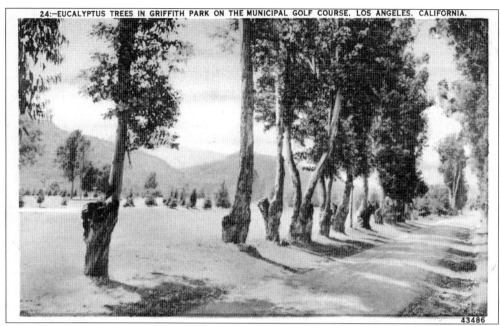

43486

This postcard provides another view of the municipal golf course. By the 1920s, as the park became more accessible, visitors enjoyed both the attractions developed on the flat lands of the park and the hiking trails located in the upper hilly regions. The park became especially popular after the advent of the Depression, when crowds of people were driven to seek out the myriad of free and inexpensive recreational activities found there.

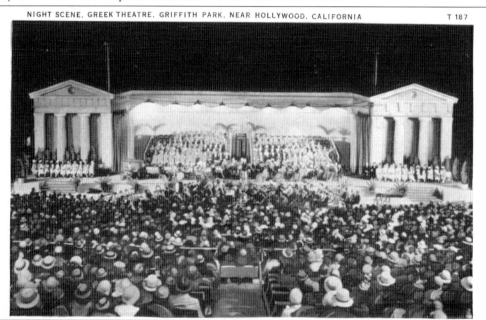

NIGHT SCENE, GREEK THEATRE, GRIFFITH PARK, NEAR HOLLYWOOD, CALIFORNIA T 187

Although the City of Los Angeles declined Griffith's offer to finance the construction of a Greek Theater while he was alive, Griffith decided to will the money to the city anyway. Years later, the city finally agreed to make use of the money, and the Greek Theater opened in 1930. Programming at the large outdoor theater consisted of plays, concerts, and pageants.

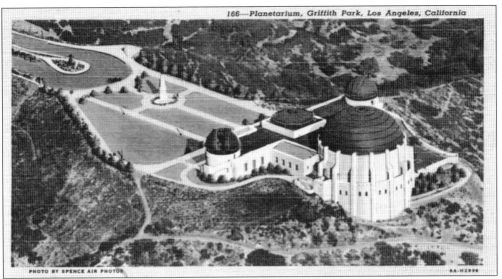

166—Planetarium, Griffith Park, Los Angeles, California

PHOTO BY SPENCE AIR PHOTOS

Griffith dreamed of having an observatory located in his park, but, as with the Greek Theater, the city rejected his offers to finance the construction during his lifetime. It was not until 1933 that the money he willed for the project began to be put to use. The Observatory was completed in 1935, with a telescope located in the east wing and a coelostat, a telescope for viewing the sun, in the west wing. In the large center dome is the planetarium, which allows a projection of the heavens to appear on the dome over the 500 seat auditorium. Lining the halls of the Observatory were a variety of scientific exhibits.

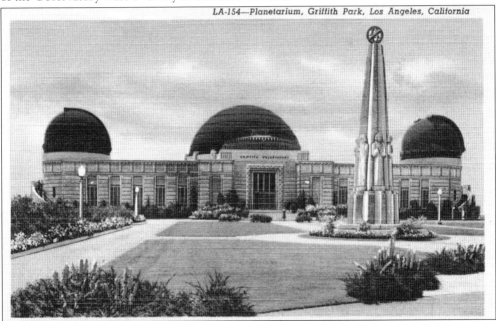

LA-154—Planetarium, Griffith Park, Los Angeles, California

The Observatory, featuring three copper domes, was designed by John C. Austin, who had participated in the design of Los Angeles City Hall. The concrete sculpture seen in front is the Astronomer's Monument, which depicts six renowned astronomers: Hipparchus, Galileo, Isaac Newton, Nicolaus Copernicus, John Kepler, and William Herschel. At the top of the obelisk is a replica of an ancient astronomical instrument.

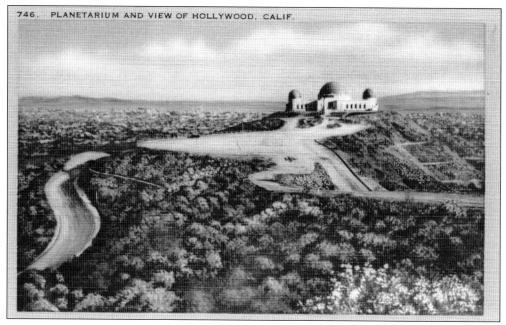

Overlooking Hollywood, the Observatory not only allowed visitors an opportunity to contemplate the sky, it also provided a vantage point for a superior panoramic view of the city below. According to Griffith's wishes, all of the educational exhibits and use of the telescope were free. A minimal admission fee was charged for the planetarium presentations.

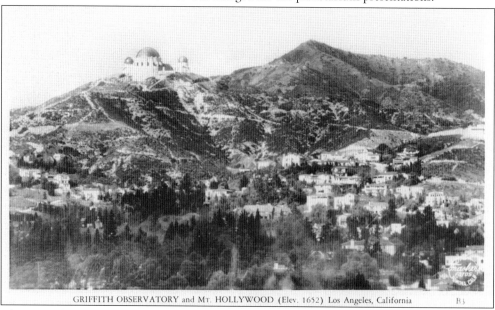

GRIFFITH OBSERVATORY and Mt. HOLLYWOOD (Elev. 1652) Los Angeles, California B3

This view shows how the hills of Griffith Park, once considered too far from the city to be of much value, had by the 1930s become an oasis surrounded by urban development. Griffith had wanted the Observatory to be constructed on the highest peak in the park, Mount Hollywood, seen at right. However, by the time construction began, the car had become the common means of transportation, and a place for roads and parking lots was needed. The Observatory was therefore located at the more accessible point seen here, just below Mount Hollywood.

94

Nine

THE WILSHIRE DISTRICT

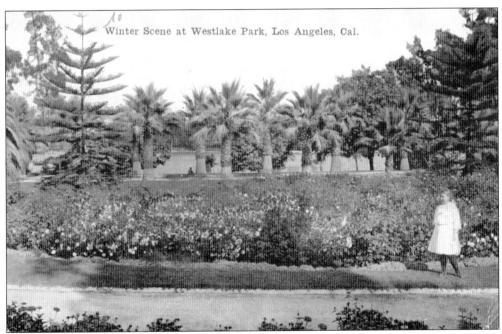

This postcard shows an early view of Westlake Park, located west of downtown Los Angeles. In 1887, Henry Gaylord Wilshire purchased 35 acres of land overlooking Westlake Park, in hopes of subdividing the land for use as an exclusive residential neighborhood. To attract buyers, Wilshire in 1895 cleared a four-block path between Westlake Park and Sunset Park for use as a boulevard. Wilshire Boulevard was gradually expanded over the next few decades, until it had become one of the city's most important thoroughfares, stretching over 15 miles from downtown Los Angeles to Santa Monica.

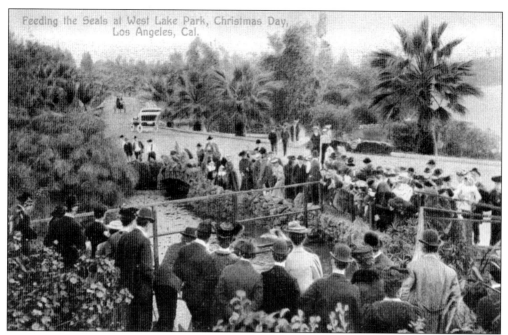

The crowds at Westlake Park are in this image watching the seals in a small pool near the park's main lake. The city of Los Angeles received the land for Westlake Park in 1886, when it was nothing more than a swamp. Over the next several years, civic efforts transformed the park into a popular retreat with a lake, walking paths, and acres of flowers and trees. After World War II, the park was renamed MacArthur Park.

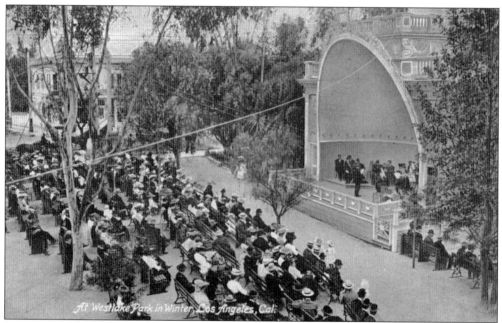

Postmarked in 1908, this postcard shows visitors to Westlake Park enjoying a free Sunday concert. A bandstand was constructed in the park in 1896, as more and more people sought a natural place to enjoy the weekend away from the growing city.

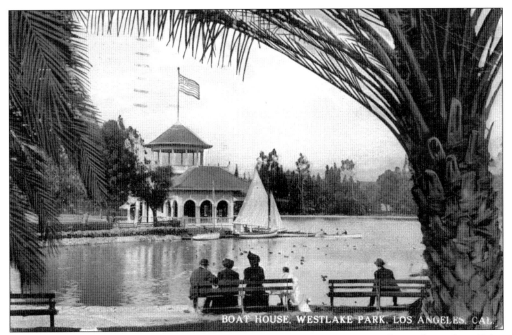

Shown here is the Westlake Park boathouse. As at other large Los Angeles parks such as Echo Park and Eastlake Park, boating was a favorite recreational activity. A sailboat and a rowboat are in view.

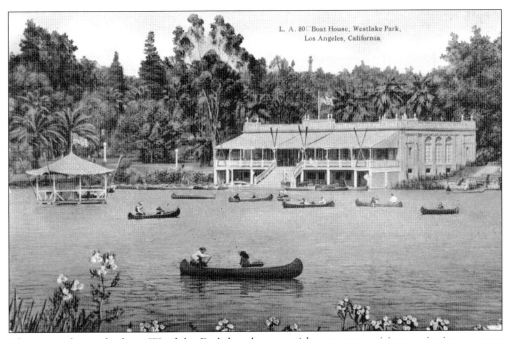

This view shows the later Westlake Park boathouse, with numerous visitors enjoying a canoe ride. The new, larger boathouse rented out boats and also included a restaurant. The park contained hundreds of trees and a series of winding paths for strolling, including one encircling the lake.

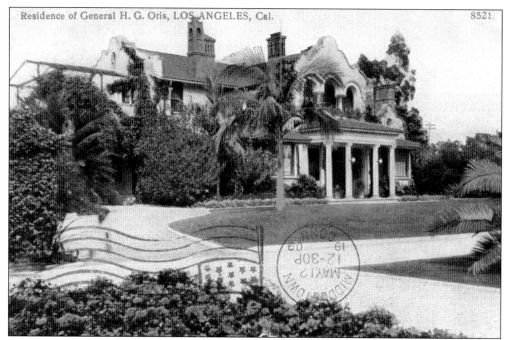

One of the first residences built on Wilshire Boulevard overlooking Westlake Park was the home of Gen. Harrison Gray Otis, publisher of the *Los Angeles Times*. Constructed in 1898, this estate helped to establish the new Wilshire neighborhood as a prestigious address. Otis willed his home to the county for use as the Otis Art Institute, which opened in 1920. Connected to the county-operated Museum of History, Science, and Art in Exposition Park, the school played a role in attracting an artistic element, including other schools and galleries, to the Westlake Park area.

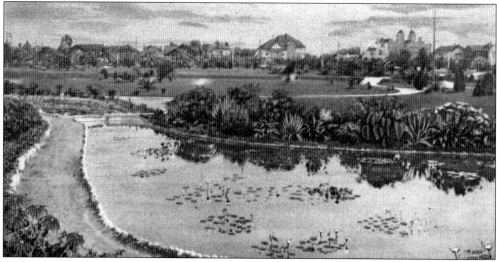

Shown here is Sunset Park, located at one end of the original four-block stretch of Wilshire Boulevard. The park was acquired in 1895 from Clara Shotto, whose husband had vast Los Angeles County land holdings. Once a muddy lot, the park was soon made over into a pleasant retreat. Some of the new exclusive residences on Wilshire Boulevard can be seen in the background.

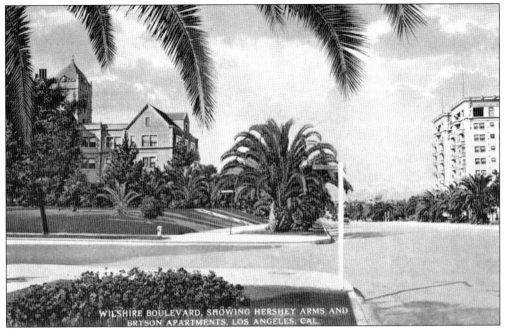

WILSHIRE BOULEVARD, SHOWING HERSHEY ARMS AND BRYSON APARTMENTS, LOS ANGELES, CAL.

This view shows a portion of Wilshire Boulevard, with the Hershey Arms Hotel on the left and the Bryson apartment building on the right. Located two blocks from the Otis home, the Hershey Arms opened in 1907 as the first commercial establishment in the Wilshire neighborhood. Soon a variety of high-end apartment and hotel buildings would be constructed on Wilshire, moving the district away from exclusively single-family residential use.

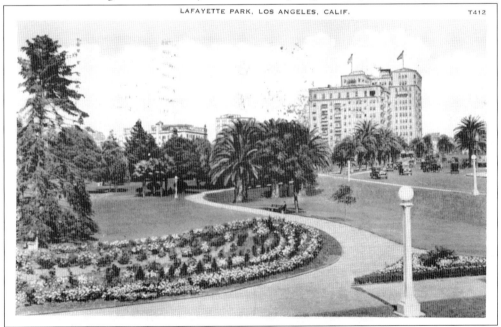

LAFAYETTE PARK, LOS ANGELES, CALIF. T412

In 1917, Sunset Park was renamed Lafayette Park in honor of Marquis de Lafayette, the Frenchman who aided the Americans during the Revolutionary War. Wilshire Boulevard is on the right, with two apartment houses in view, the Rampart and the Arcady.

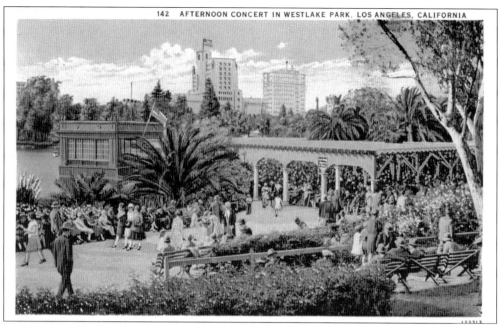

Postmarked in 1929, this postcard shows a crowd of people that have gathered near the boathouse. The largest building in the background is one of the most notable to have been constructed overlooking the lake. Built in 1925 in Egyptian Revival style, the 11-story structure was used as Elks Lodge No. 99.

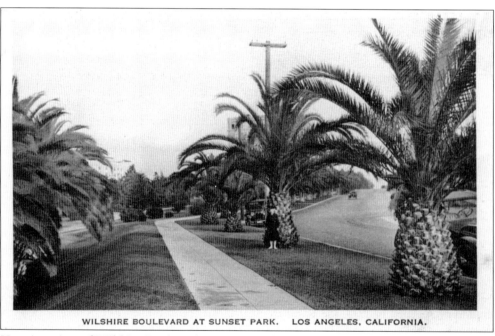

WILSHIRE BOULEVARD AT SUNSET PARK. LOS ANGELES, CALIFORNIA.

Here is a view of Wilshire Boulevard at Sunset Park. As cars became more popular, the city began expanding and paving the boulevard. After 1927, the city completed the construction of sidewalks and planting of palm trees along the boulevard, as seen in this image.

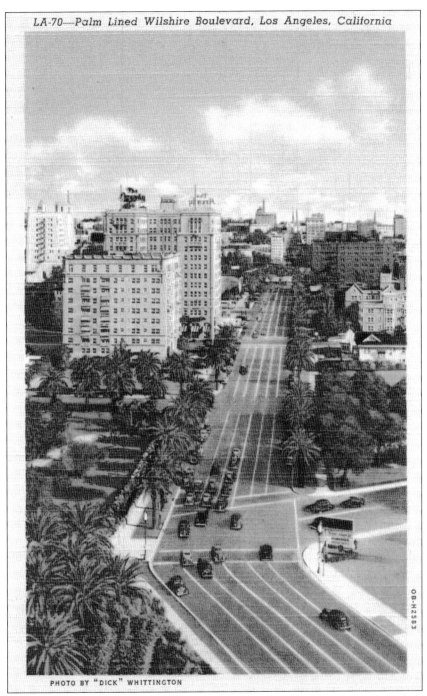

LA-70—Palm Lined Wilshire Boulevard, Los Angeles, California

PHOTO BY "DICK" WHITTINGTON

Shown here is Wilshire Boulevard's new skyline of exclusive residential hotels and apartment buildings. Opened in 1910, the Rampart Apartments are in the left foreground, adjacent to Sunset Park and across from the Hershey Arms. The tallest building on the left is the Arcady, a residential hotel opened in 1927. Visible also is the 45-degree turn Wilshire Boulevard was given when it was extended from its original Sunset Park terminus a few years after its establishment.

Western Ave., north from Wilshire, Los Angeles, California. No. 173.

Depicted in this image are early business developments at the intersection of Wilshire Boulevard and Western Avenue. Home first to family estates, then to fine apartment hotels, the Wilshire neighborhood would soon change again into a thriving shopping district. This intersection, here lined only with small businesses, would become one of the busiest in the city.

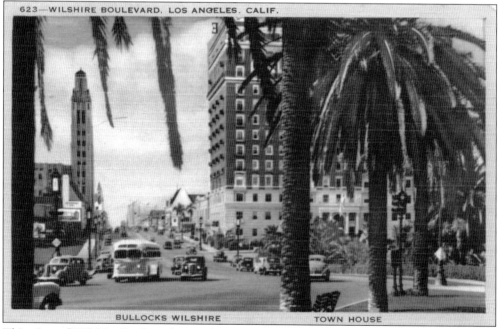

623—WILSHIRE BOULEVARD, LOS ANGELES. CALIF.

BULLOCKS WILSHIRE TOWN HOUSE

This view of Wilshire Boulevard was taken from Lafayette Park, showing two of the district's new landmarks. On the left is Bullocks Wilshire, which was dedicated in 1929 as an exclusive department store. The Town House apartment hotel, on the right, also opened in 1929 and soon became known as one of the most prestigious addresses. As cars became the favored means of transportation, many stores began opening branches in the open spaces of Wilshire Boulevard, away from the congestion of downtown.

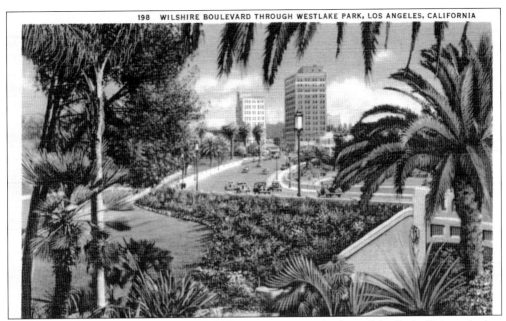

Until the 1930s, Wilshire Boulevard terminated at each end of Westlake Park. Drivers had to use side streets to bypass the park and then reconnect with the boulevard on the other side. A California Supreme Court decision finally allowed the city to connect the two segments by constructing a road through the park. Officially opened in 1934, the new curving section of road eased traffic problems, at the cost of having split the park into two portions.

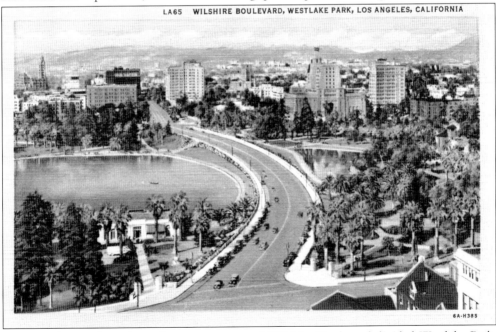

This aerial view shows how the new segment of Wilshire Boulevard divided Westlake Park. The lake is now much smaller, and many of the walking paths and natural scenery were lost. The boathouse can be seen on the lakeshore at left, and the Elks Lodge overlooks the small segment of lake on the right.

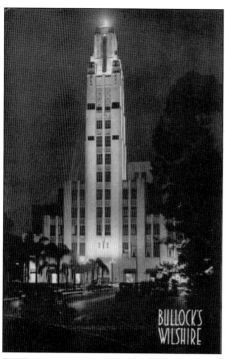

Bullocks Wilshire, a high-end department store, opened on Wilshire Boulevard in 1929. The striking art deco building with its 241-foot spire was designed to attract the attention of customers arriving by car. The success of Bullocks Wilshire led other major retailers to locate on Wilshire, and by World War II, the boulevard had become one of the most popular shopping destinations in the city.

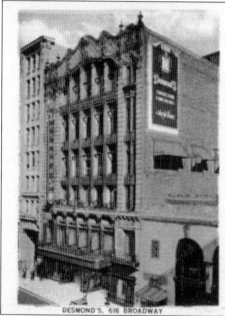

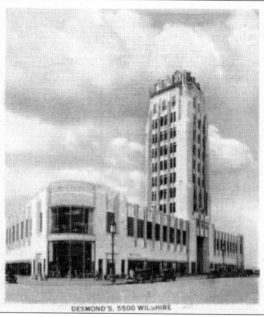

DESMOND'S, 616 BROADWAY

DESMOND'S, 5500 WILSHIRE

On the right is a view of the Wilshire Tower building, constructed in 1929. The building was shared by two department stores: Desmond's in the east wing and Silverwoods in the west wing. The Desmond's on Wilshire, at right, demonstrates how architecture on Wilshire Boulevard was styled to catch the eye of motorists. This can be contrasted with the style of the store at left, found in the downtown shopping district of Los Angeles. In the traditional downtown setting, where customers walked between stores, it was not the building itself but rather the window displays that were used to draw shoppers.

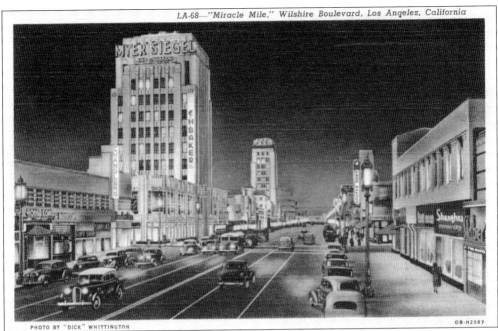

PHOTO BY "DICK" WHITTINGTON OB-H2587

This postcard shows the Miracle Mile shopping district on Wilshire Boulevard. Myer Siegel, at left, was a popular women's store founded in 1886. They opened this branch on Wilshire in 1931, two blocks away from Desmond's and Silverwoods, seen on the left in the background. The top floors of both towers were used as office space.

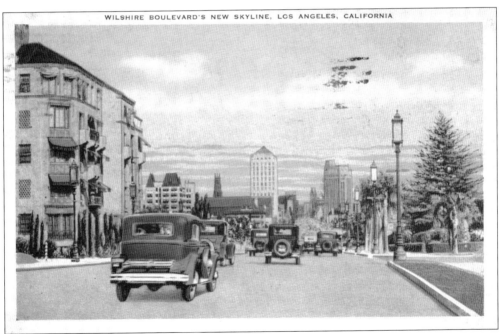

WILSHIRE BOULEVARD'S NEW SKYLINE, LOS ANGELES, CALIFORNIA

Postmarked in 1934, this postcard shows another view of the growing Wilshire district. Wilshire was lined in 1928 with custom-built streetlights, visible on the right. The boulevard was also the sight of the city's first synchronized traffic lights, installed in 1931.

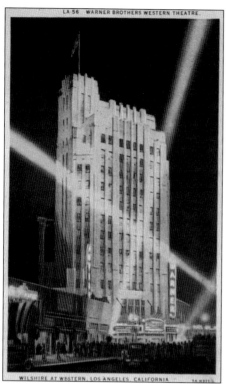

The Warner Brothers Western Theater opened on October 7, 1931, at the corner of Wilshire Boulevard and Western Avenue, one of the district's busiest intersections. Though closed for several years during the Depression, the theater later reopened as the Wiltern. Covered with custom-glazed aqua-green tiles, the Pellissier Building housed both the movie theater at ground level and a variety of professional offices on the upper floors.

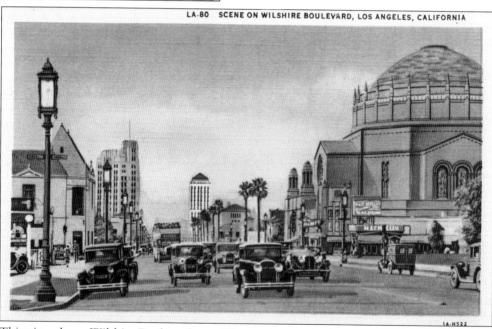

This view shows Wilshire Boulevard near Western Avenue in the 1930s. The domed Wilshire Boulevard Temple, dedicated in 1929, is at right, and the Pellissier Building is visible on the left. As many motorists chose to avoid downtown Los Angeles by the end of the 1930s, Wilshire Boulevard became known as the way of the future, making the boulevard not only a popular shopping district, but also a prized business address.

Ten

BEACHES

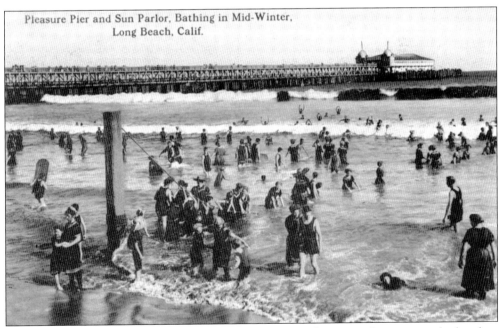

Pleasure Pier and Sun Parlor, Bathing in Mid-Winter,
Long Beach, Calif.

Shown here is a 1913 view of Long Beach, one of Los Angeles County's many popular beaches. Long Beach, with more than 8 miles of beach, was home to a variety of amusements, including the first municipal pier in the state, opened in 1893. This pier was replaced by a new double-deck pleasure pier, seen here, in 1904.

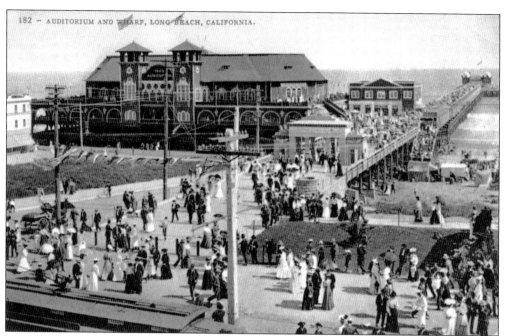

This view depicts the Auditorium, located adjacent to the pier and dedicated on November 15, 1905. The Auditorium replaced the earlier Pavilion, which had burned in January 1905. At the end of the pier is the Sun Parlor, a small glass-enclosed pavilion constructed in 1905. Both the Auditorium and the Sun Parlor were popular places for dancing.

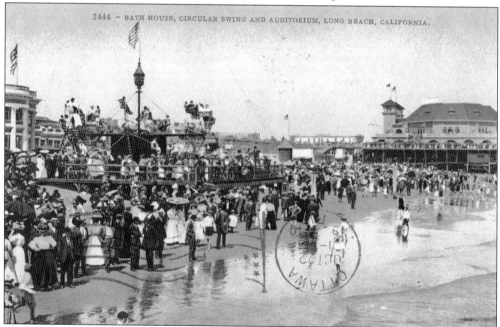

2444 — BATH HOUSE, CIRCULAR SWING AND AUDITORIUM, LONG BEACH, CALIFORNIA.

This 1910 postcard shows the crowded beach next to the pier and the Auditorium. This area was the center of an amusement zone known as the Pike, where a variety of rides, shops, and concessions could be found. The ride in view here is the Circular Swing, which was similar to a Ferris wheel.

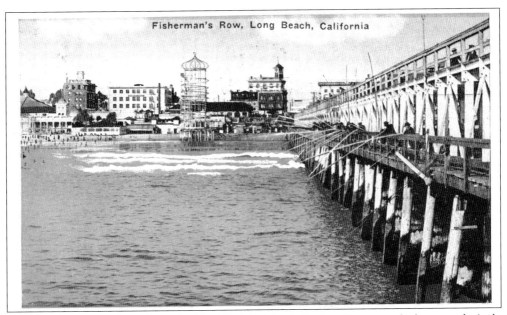

This view was taken from the end of the 1904 double-deck pier. The upper deck was exclusively for pedestrian use, while the lower deck featured a vehicle driveway, with pedestrian walkways on either side. The tall ride seen on the beach was Bisley's Spiral Airship, also known as the Spiral Way. The ride, built in 1910, propelled passengers to the top of the tower in a car, which then wound back down in a spiral pattern.

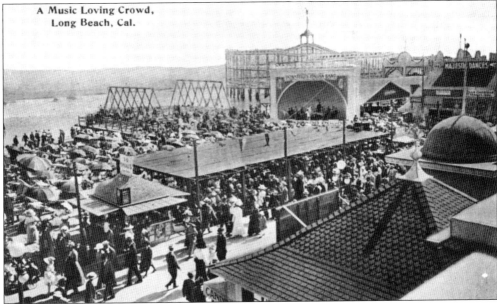

This postcard shows the crowds at Long Beach, with Donatelli's Italian Band playing in the band shell. Free concerts were held at the band shell in summer and at the Auditorium in winter. The band was supported by revenues from dances at the Auditorium until 1911, when a special city tax created a municipally supported band. In the background is a small roller coaster, a favorite pier attraction from 1907 to 1914, when it was dismantled to make way for a larger coaster.

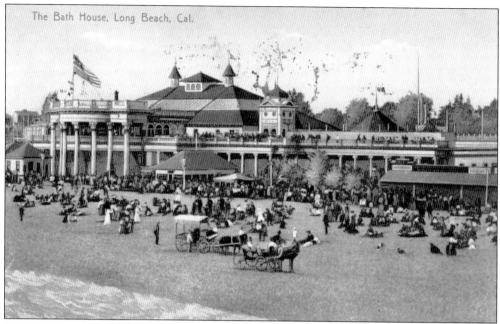

The Long Beach Bath House opened on July 4, 1902, the same day the new Pacific Electric line from downtown Los Angeles to Long Beach began operation. The influx of tourists and new residents that began arriving caused Long Beach to become one of the fastest growing cities in the country. In this early view, visitors were still able to enjoy the beach by horse and buggy.

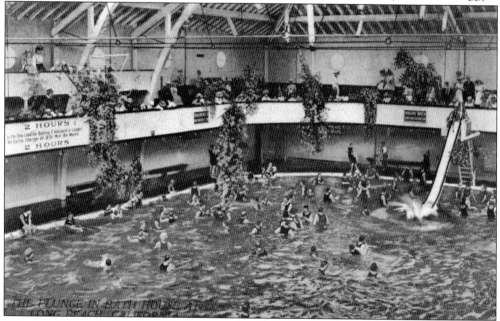

This view shows the interior of the Long Beach Bath House. The saltwater plunge was heated, making it popular for those not wishing to swim in the cooler ocean waves. The Long Beach Bath House and Amusement Company played a key role in having the Pacific Electric line constructed and continued to be involved in developing the surrounding amusement area by constructing a boardwalk and beach cabanas.

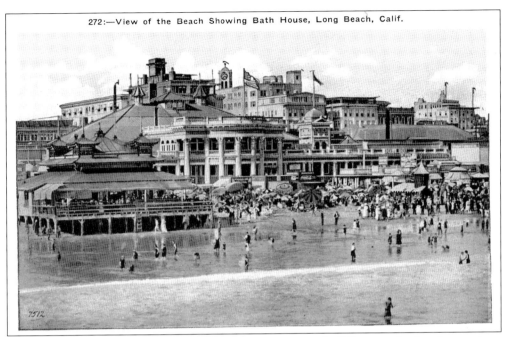

The Long Beach Bath House, once the most prominent building on the beach, was later surrounded by the various larger buildings of the growing city. As new additions to the Pike were made, the number of yearly visitors to Long Beach rose to the hundreds of thousands.

Bamboo Slide, Long Beach, Calif.

This card, postmarked 1922, shows the Bamboo Slide, which had been built a few years earlier on the site formerly occupied by the Spiral Way. A popular ride in a prime location next to the pier, the Bamboo Slide provided visitors with jute mats for their ride down the winding slide.

Shown here is the crowded Long Beach boardwalk and the Jackrabbit Roller Coaster. This ride replaced the smaller 1907 coaster, opening in 1915 to compete with the popular Race Thru the Clouds coaster a few miles away in Venice. A larger double-track racer called the Cyclone replaced the Jackrabbit in 1930.

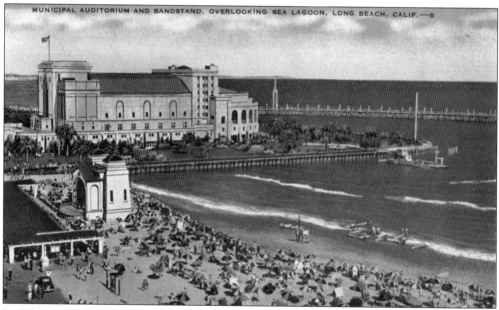

MUNICIPAL AUDITORIUM AND BANDSTAND, OVERLOOKING SEA LAGOON, LONG BEACH, CALIF.—8

In 1931, the Auditorium was demolished, replaced by the much larger Long Beach Municipal Auditorium seen here. Dedicated in 1932, the new auditorium was surrounded by a crescent-shaped pier, known as the Rainbow Pier, which enclosed 32 acres of water for use as a still-water lagoon. The nearby 1904 double-deck pier continued to be used for a few years until it was destroyed by a 1934 storm. The new auditorium was used for operas, sports events, musicals, conventions, art exhibits, and other social gatherings.

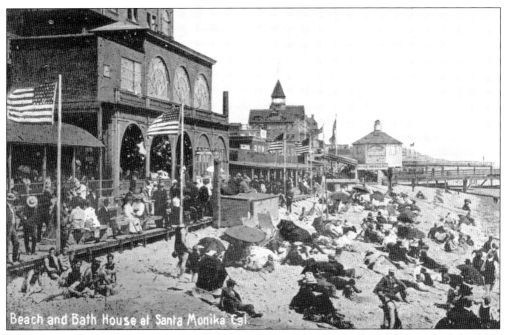

Santa Monica has been a popular beach resort since its founding in the 1870s. At the left of this image is the North Beach Bath House. Built in 1894, this popular facility contained a heated saltwater pool, a restaurant, and a bowling pavilion. The small building at right on the beach housed a camera obscura. The tallest building in the background is the Arcadia Hotel, a resort with its own bathhouse.

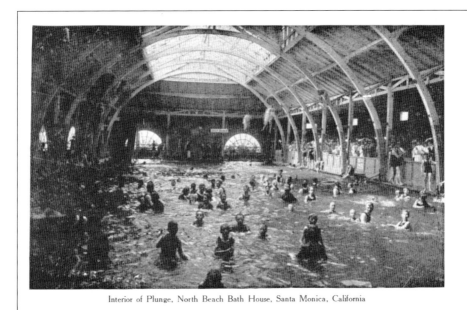

Interior of Plunge, North Beach Bath House, Santa Monica, California

WOOD'S PRINT, L. A.

This view shows the interior of the North Beach Bath House. Swimming in the heated saltwater baths was not just for amusement; it was also advertised to have numerous health benefits.

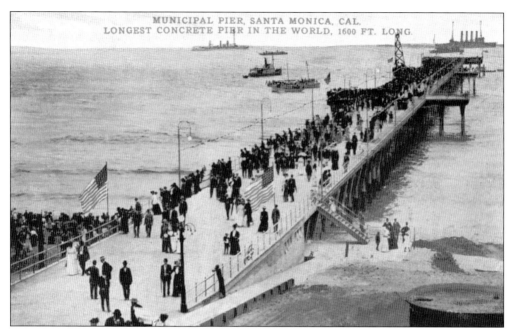

Shown here is the concrete Santa Monica municipal pier, dedicated in 1909. Though not as long as the pier at the North Beach Bath House, the municipal pier would soon be home to a much wider set of attractions. The concrete pilings, widely hailed upon the pier's opening, soon corroded and were replaced with wood.

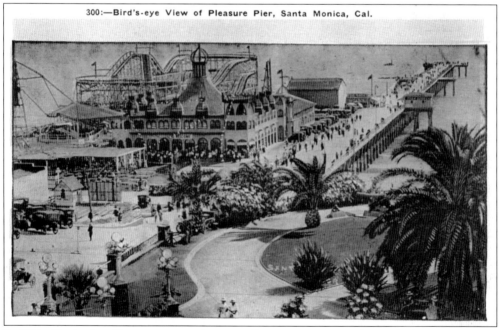

300:—Bird's-eye View of Pleasure Pier, Santa Monica, Cal.

In 1916, Charles Looff began constructing a smaller amusement pier alongside the Santa Monica municipal pier. The large building in view is the Hippodrome, which housed a carousel. The Looff pier featured a variety of rides and attractions, including a roller coaster.

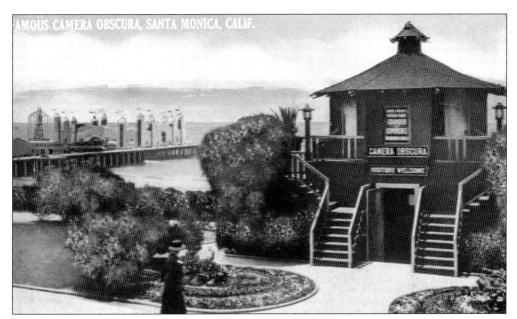

FAMOUS CAMERA OBSCURA, SANTA MONICA, CALIF.

Shown here is the camera obscura after it had been relocated from the North Beach Bath House to Linda Vista Park, renamed Palisades Park in the 1920s. The camera obscura was a popular attraction where visitors could enter the dark chamber and view a color projection of the scene outside, via a series of revolving lenses, prisms, and mirrors. The Santa Monica and Looff piers are visible to the left, now crowned by the huge La Monica Ballroom.

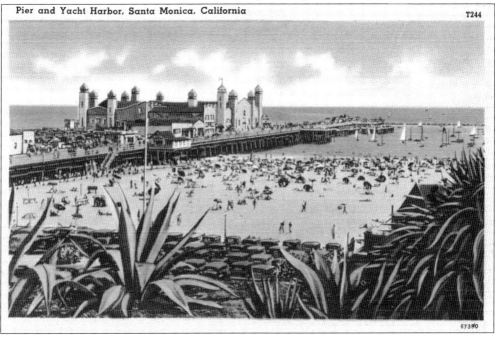

Pier and Yacht Harbor, Santa Monica, California T244

This 1930s view shows the Santa Monica pier and the La Monica Ballroom. Built in 1924, the ballroom was capable of accommodating 10,000 people at its popular dances. Many of the earlier pier attractions and rides, including the roller coaster, were removed by 1930. In 1934, a breakwater was built off the pier, creating a smooth harbor for yachting and sailing.

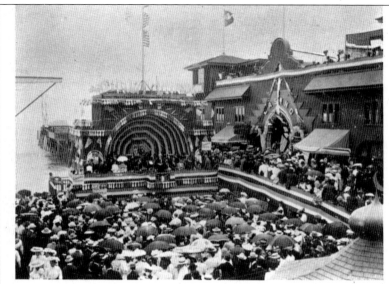

BAND STAND AND CASINO, OCEAN PARK, CALIFORNIA

SEWARDS' POST CARDS, L. A.

This postcard shows the bandstand and the Casino restaurant and theater in Ocean Park, with a small pier extending in the background behind the bandstand. Ocean Park began as a resort town founded by partners Abbot Kinney and Francis Ryan in 1885 on a tract of land just south of Santa Monica. After Ryan's death in 1889, his share of the partnership passed into the hands of Alexander Fraser, Henry Gage, and George Merritt Jones.

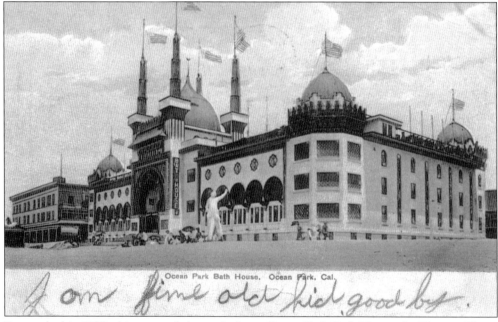

Ocean Park Bath House, Ocean Park, Cal.

Postmarked in 1908, this postcard shows the large Ocean Park Bath House. As Kinney did not get along with his new partners, the land was divided in 1904. Kinney became sole owner of the undeveloped southern half of the original tract, with the other three receiving the Ocean Park development. One of the new owners' first improvements was the construction of this bathhouse in 1905, opening the same weekend as Kinney's new resort to the south, Venice of America.

116

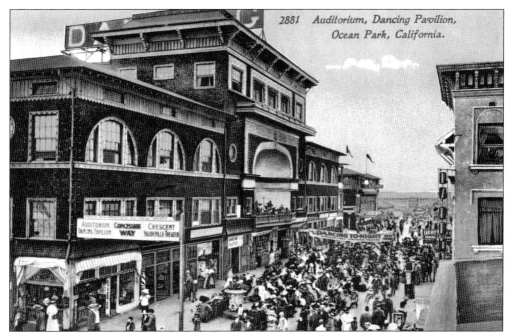

This view shows the Ocean Park Auditorium and Dance Pavilion, constructed in 1906. The Casino is adjacent, near the oceanfront. A variety of other concessions and attractions, including the Crescent Vaudeville Theater, have been added as the new owners continued to expand the resort town.

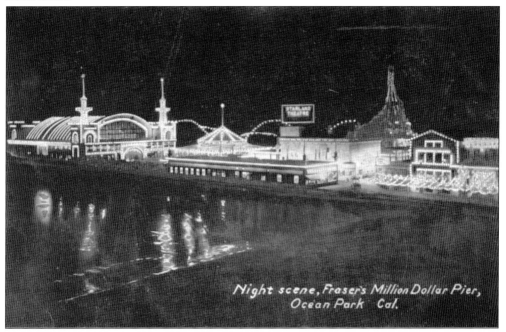

Fraser's Million Dollar Pier was constructed by Alexander Fraser in 1911 to compete with Kinney's successful amusement zone in Venice. On the left at the end of the pier is a huge dance pavilion. The pier also included the Starland Vaudeville Theater, a carousel, and the Grand Canyon Scenic Railway, the outline of which can be seen at the far side of the pier.

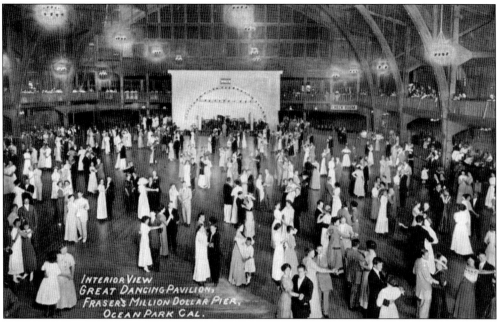

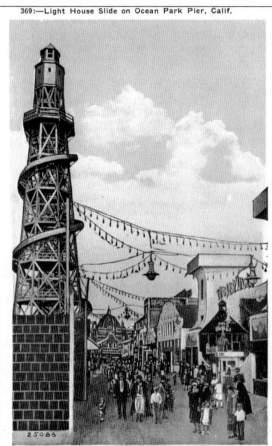

369:—Light House Slide on Ocean Park Pier, Calif.

25086

Shown here is the interior of the dance pavilion on Fraser's Million Dollar Pier. In 1912, a devastating fire destroyed the entire pier, including the dance pavilion and all the amusements. Fraser quickly rebuilt, opening a new pier in May 1913.

In 1924, the pier built by Fraser in 1913 was destroyed by another fire. Shown here is the new Ocean Park pier, opened in 1925. Amusements included the Lighthouse Slide, the Toonerville fun house (seen at right), a theater, a carousel, and other rides.

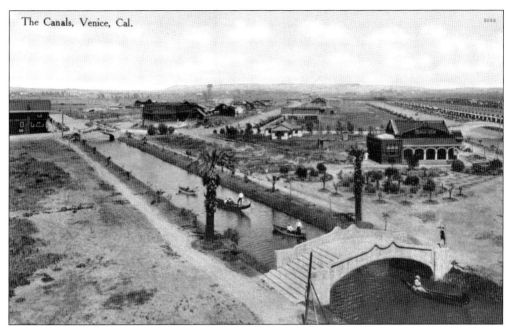

The Canals, Venice, Cal.

When the Ocean Park tract was divided in 1904, Abbot Kinney, now the sole owner of the undeveloped southern half, was finally able to begin construction on the town of his dreams. Named Venice of America, Kinney based his new resort on the Italian Venice, hoping to create a place of cultural renaissance. From the sand dunes and marshland, Kinney began dredging a system of canals, complete with romantic arched bridges.

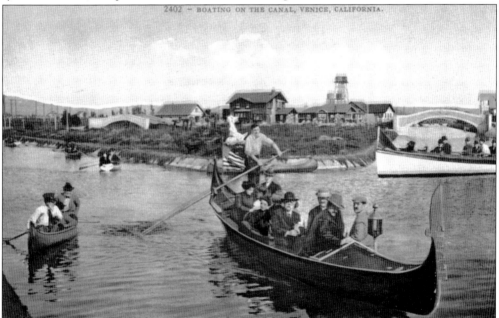

2402 – BOATING ON THE CANAL, VENICE, CALIFORNIA.

This postcard, postmarked in 1910, shows a group of visitors enjoying a gondola ride on one of Venice's canals. To add authenticity, Kinney had imported two dozen gondoliers from Italy. The new resort was immediately popular, with over 40,000 people attending the grand opening on July 4, 1905.

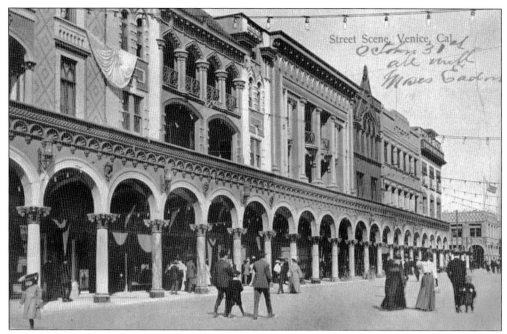

Shown here is Venice's main street, Windward Avenue, which connected the canals with the beach and the amusement pier. Marked by Italian-style architecture, the avenue featured shops, restaurants, and hotels. At many Venice hotels, visitors could enjoy the supposed health benefits of having hot saltwater piped to each room.

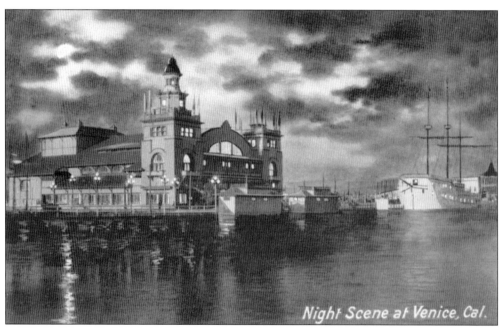

Shown here is the 3,600-seat Venice Auditorium, located at the end of the pier. Rebuilt in just 28 days after a 1905 storm destroyed the original construction work, the auditorium was meant to be the home of a series of educational and cultural events. The series lasted only one season, however, as visitors preferred the beach, gondola rides, and other amusements.

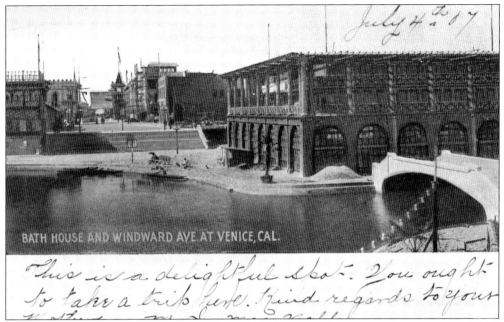

BATH HOUSE AND WINDWARD AVE. AT VENICE, CAL.

This 1907 postcard shows the original Venice Bath House, on the right next to Windward Avenue. The bathhouse was constructed next to a swimming lagoon so visitors could either swim in the outdoor lagoon or in the indoor heated pool. When Kinney decided to build a bathhouse on the beach in 1908 in order to focus the amusement zone around the pier and the beach, this bathhouse was converted for use as a high school.

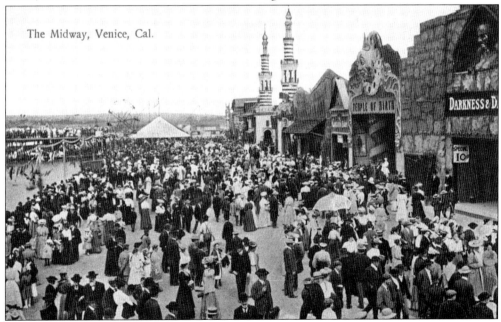

The Midway, Venice, Cal.

The Midway Plaisance, a series of carnival-like sideshows, was located along the edge of the swimming lagoon. Opened in Venice in 1906, Kinney had the attraction brought after it had finished its run at the Lewis and Clark Exposition in Portland. In order to concentrate the amusements around the pier, the midway attractions were moved to the pier in 1907.

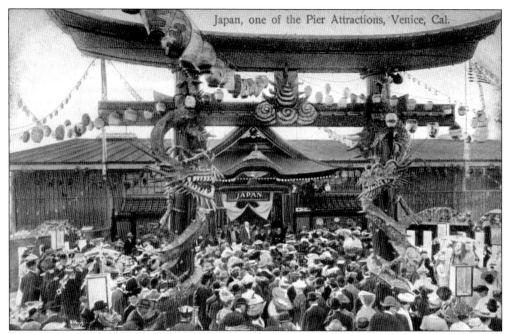

This view shows a Japanese exhibit at the Pavilion, a one-story exhibit hall and ballroom near the Venice pier. Like the midway, the Japanese exhibit was brought by Kinney from the Lewis and Clark Exposition in Portland. Visitors to the exhibit could examine Japanese cultural artifacts and artwork.

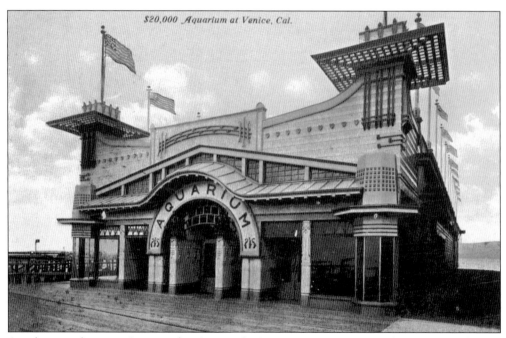

$20,000 Aquarium at Venice, Cal.

Another popular attraction near the pier was the Venice Aquarium, opened in 1909. In addition to providing shows and exhibits of marine life for tourists, the aquarium was used by the University of Southern California as a research station.

The Ship Café, a popular restaurant, was located on the south side of the Venice Pier, between the Auditorium and the Dance Pavilion. Constructed on pilings, the ship was modeled after the Spanish galleon of explorer Juan Cabrillo.

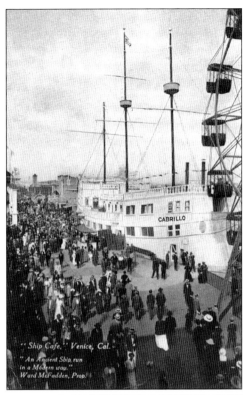

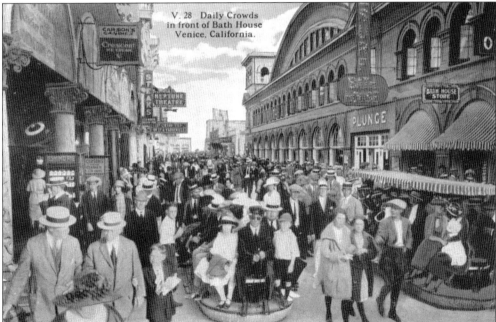

The new Venice Bath House, seen on the right of this image, opened on the beach in 1908. The electric trams seen on the concrete promenade carried visitors between the Venice and Ocean Park amusement areas, less than a mile apart. On the left is a sign for the Neptune Theater, a movie house. The Auditorium on the pier was also frequently used to show movies.

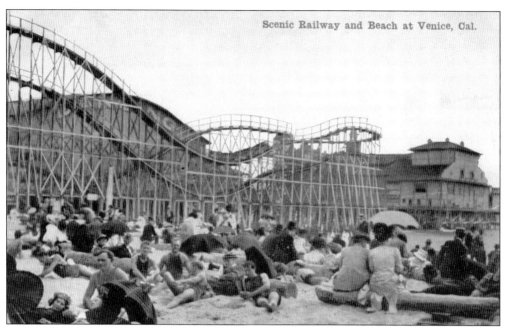

This 1912 postcard shows visitors enjoying the Venice beach, with the Scenic Railway roller coaster behind. Constructed by the L. A. Thompson Company in 1910, the roller coaster occupied the north side of Kinney's amusement pier. The dance pavilion and auditorium are visible on the other side of the roller coaster.

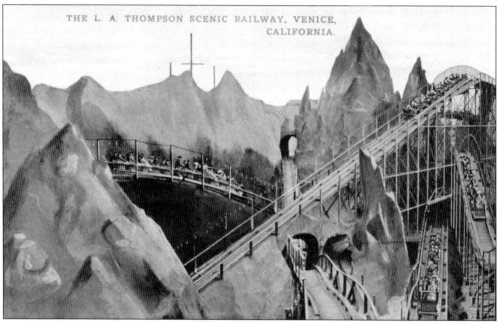

THE L. A. THOMPSON SCENIC RAILWAY, VENICE, CALIFORNIA.

Here visitors are enjoying a ride on the mile-and-a-half Thompson Company Scenic Railway, built on the pier. Though Kinney had hoped to create an environment fostering education and cultural renaissance, it was the beach and pier amusements that proved most popular. Venice enjoyed the height of its popularity in the 1910s, with new rides, concessions, and attractions added each year.

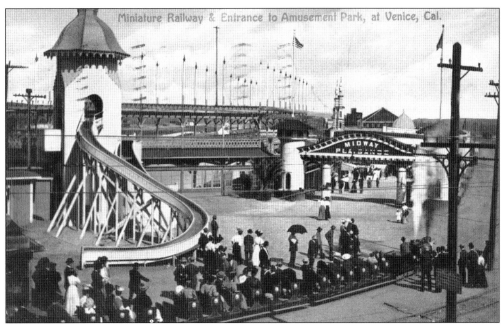

Postmarked in 1908, this postcard shows the miniature railway approaching the entrance to the Midway Plaisance. Designed by John Coit, a retired Southern Pacific engineer, the train was exactly like a locomotive, only in miniature. Impressed by the miniature railway Coit operated in Eastlake Park, Kinney hired him in 1906 to construct a line in Venice. Operating in a loop through Venice's residential and amusement districts, the railway provided a means of both transportation and sightseeing.

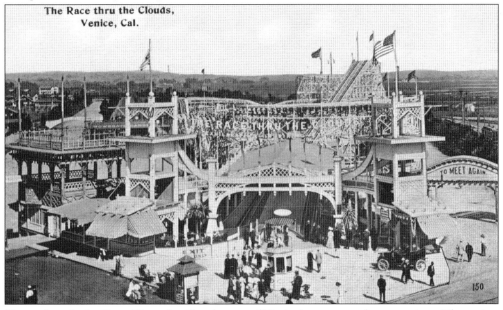

Shown here is the Race Thru the Clouds, one of Venice's most popular attractions. The racing coaster was constructed by Tom Prior near the swimming lagoon, where the Midway Plaisance had been before it was moved to the pier. Prior employed jazz bands and other entertainment in order to attract riders to the coaster.

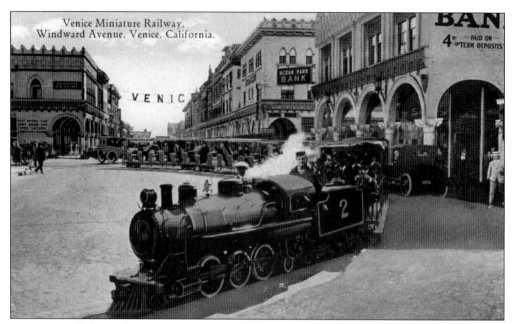

This postcard shows the Venice miniature railway on Windward Avenue. The railway was an ideal means of transportation, as the small track fit easily on the banks of the canals and on the small arched bridges. Ridership fell in the 1920s, however, as cars became increasingly popular. Part of the lagoon was filled in to provide a parking lot, and with talk of filling in the canals to create boulevards, the railway was dismantled in 1925.

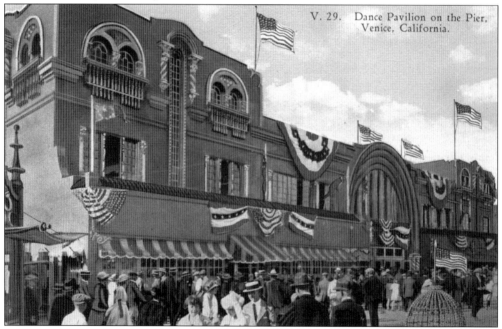

A month after Abbott Kinney's death in November 1920, a fire destroyed the Venice pier and all the amusements. This view shows the rebuilt dance hall, opened in 1921 along with a new pier and a host of other new attractions. Although many of the canals were filled in to create roads in 1929, Venice remained a popular place to visit until the pier closed in 1946.

BIBLIOGRAPHY

Case, Walter. *History of Long Beach*. Long Beach, CA: Press-Telegram Publishing Company, 1935.

Eberts, Mike. *Griffith Park: A Centennial History*. Los Angeles, CA: The Historical Society of Southern California, 1996.

Emler, Ron. *Ghosts of Echo Park*. Los Angeles, CA: Echo Park Publishing Company, 1999.

Grenier, Judson, ed. *A Guide to Historic Places in Los Angeles County*. Dubuque, IA: Kendall/Hunt Publishing Company, 1978.

History Division of the Los Angeles County Museum. *Los Angeles 1900–1961*. Los Angeles, CA: The Division, 1962.

Mackey, Margaret Gilbert. *Going Places in and near Los Angeles*. Los Angeles, CA: Goodwin Press, 1947.

Moran, Tom, and Tom Sewell. *Fantasy by the Sea*. Culver City, CA: Peace Press, 1980.

Phillips, Alice. *Los Angeles: A Guide Book*. Los Angeles, CA: The Neuner Company, 1907.

Robinson, W. W. *The Story of Pershing Square*. Los Angeles, CA: Title Guarantee and Trust Company, 1931.

Roderick, Kevin. *Wilshire Boulevard: Grand Concourse of Los Angeles*. Santa Monica, CA: Angel City Press, 2005.

Seims, Charles. *Mount Lowe: The Railway in the Clouds*. San Marino, CA: Golden West Books, 1976.

Taylor, Katherine Ames Taylor. *The Los Angeles Tripbook*. New York: The Knickerbocker Press, 1928.

Torrence, Bruce T. *Hollywood: The First Hundred Years*. New York: New York Zoetrope, 1982.

Van Tuyle, Bert. *Know Your Los Angeles*. Los Angeles, CA: Know Your California, 1938.

Workers of the Writer's Program of the Works Project Administration. *Los Angeles: A Guide to the City and Its Environs*. New York: Hastings House, 1951.

ACROSS AMERICA, PEOPLE ARE DISCOVERING SOMETHING WONDERFUL. *THEIR HERITAGE.*

Arcadia Publishing is the leading local history publisher in the United States. With more than 4,000 titles in print and hundreds of new titles released every year, Arcadia has extensive specialized experience chronicling the history of communities and celebrating America's hidden stories, bringing to life the people, places, and events from the past. To discover the history of other communities across the nation, please visit:

www.arcadiapublishing.com

Customized search tools allow you to find regional history books about the town where you grew up, the cities where your friends and family live, the town where your parents met, or even that retirement spot you've been dreaming about.